IMAGES
of America

USS NEW MEXICO
BB-40

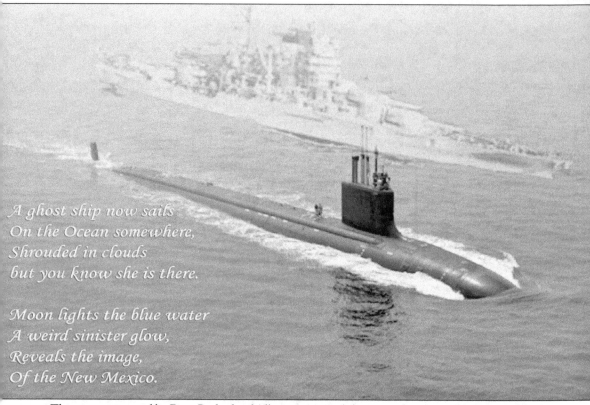

A ghost ship now sails
On the Ocean somewhere,
Shrouded in clouds
but you know she is there.

Moon lights the blue water
A weird sinister glow,
Reveals the image,
Of the New Mexico.

This picture, created by Dave Peabody of Albuquerque, and the poem that accompanies it, imagine the nuclear attack submarine USS *New Mexico* (SSN-779) escorting the battleship USS *New Mexico* (BB-40). Many of the photographs in this book have been taken from cruise scrapbooks assembled by various crew members. The US Navy provided sets of photographs to sailors for inclusion in these scrapbooks, so these images are credited to the Navy. (Dick Brown.)

ON THE COVER: USS *New Mexico* leads the Victory Fleet in a column of nine battleships on April 13, 1919, off the coast of Virginia. The next two ships astern are USS *Oklahoma* (BB-37) and USS *Nevada* (BB-36). (US Navy.)

IMAGES
of America

USS NEW MEXICO
BB-40

John Taylor, Richard Melzer, Dick Brown, and Greg Trapp

ARCADIA
PUBLISHING

Published by Arcadia Publishing
Charleston, South Carolina

Library of Congress Control Number: 2017953091

For all general information, please contact Arcadia Publishing:
Telephone 843-853-2070
Fax 843-853-0044
E-mail sales@arcadiapublishing.com
For customer service and orders:
Toll-Free 1-888-313-2665

Visit us on the Internet at www.arcadiapublishing.com

This book celebrates the 100th anniversary of the launching and commissioning of USS New Mexico and is dedicated to the memory of the men who proudly served aboard her.

CONTENTS

FOREWORD

My battle station was in the powder-handling compartment inside Turret No. 2. As a member of an 80-man gun crew, I knew I was performing an important duty, and I was reminded of that every time I heard the thunderous boom and felt the explosive concussion of our 14-inch guns sending three-quarter-ton projectiles to an enemy 20 miles away.

This is the story of USS *New Mexico* (BB-40), a battleship with a glorious history. It describes the advent of battleships like BB-40 and how they evolved from a long line of ships-of-the-line, how *New Mexico* was built, from her keel plates to the top of her masts and from her clipper bow to the floatplane catapults on her stern, and how she proudly showed our flag across two oceans. In a way, this is a memorial to a majestic ship that earned the titles "Queen of the Seas" and "Flagship of the Pacific Fleet." The pages that follow offer a rare look at her inner workings, shipboard life, and her role in taking the fight to the enemy after the surprise attack on Pearl Harbor.

At the age of 19, I enlisted in the Navy. The year was 1942. After basic training, I traveled to Bremerton, Washington, and reported aboard a huge ship named after my home state. To my surprise, of the 2,000 sailors onboard, I was one of only two from New Mexico. The other fellow was a Native American from a northern New Mexico pueblo. I took special pride in my personal connection with USS *New Mexico*, not for the $21-per-month pay but for the opportunity to serve my country in a time of great need.

New Mexico was one of the fiercest fighting ships in the Pacific theater. I witnessed two kamikaze attacks, one killing my captain and 29 others on the bridge, and yet *New Mexico* never stopped fighting. My shipmates and I were anchored near USS *Missouri* when Japan surrendered. I stayed onboard for the ship's triumphant return to Boston in 1945—all described in these pages—and it was there that I mustered out of the Navy. Not that I was counting, but I served three years, three months, and two days.

This historical account of the battleship *New Mexico* is the work of four credible, dare I say incredible, authors addicted to battleship history. One is a former naval officer, another is a history professor, and another is a battleship *New Mexico* artifact collector and historian. And there is one more—a former submariner who is largely responsible for the battleship's legacy living on in the steel hull of one of the US Navy's newest attack submarines, USS *New Mexico* (SSN-779). What would I like to say to that submarine crew? I'd say, "Shipmates, you have the watch now. I salute you as you carry our name and continue our noble legacy, protecting our freedoms and defending our nation, as the Queen did so very long ago."

—James R. Kennedy, Gunner's Mate Second Class
USS *New Mexico* (BB-40), 1942–1945
Cedar Crest, New Mexico

ACKNOWLEDGMENTS

The authors gratefully acknowledge the assistance provided by Lt. Comdr. Damon Runyan (USN, ret.) and Capt. Rod Stewart (USN, ret.). Many of the images are official US Navy photographs—these are designated as USN in the text. Others are taken from various cruise scrapbooks compiled by men who served aboard *New Mexico* and collected by Greg Trapp and Richard Melzer. Nancy Tucker also generously provided valuable postcards. We also wish to thank our wives, Lynn, Rena, Donna, and Tonia, for their perseverance and patience while we were "out to sea on extended duty" aboard *New Mexico*.

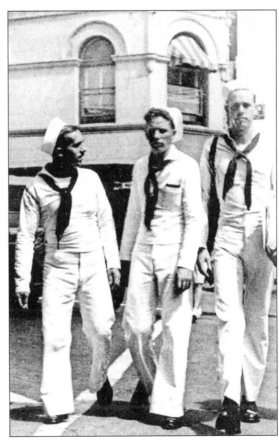

On liberty in Honolulu in 1943 are James Kennedy (center, author of the foreword), his brother Martin, a submarine sailor (right), and a Native American sailor named Bigknee from an Eastern tribe (left). (James Kennedy family.)

INTRODUCTION

The battleship paralleled the shoreline. Gunners trained her 14-inch guns on the heavily reinforced Japanese gun emplacements that controlled the beaches below. Her smaller five-inch guns blazed away at the kamikaze pilots who attacked from all sides like a swarm of bees. The battleship was the 32,000-ton USS *New Mexico* (BB-40), the scene was the Lingayen Gulf off the island of Luzon in the Philippines, and the date was January 6, 1945.

No great power in the history of the world has survived for long without paying close attention to control of the seas. At the peak of its power, ancient Athens had 400 ships and 80,000 sailors. The Venetian fleet dominated the Mediterranean for centuries; Spanish and Portuguese men-of-war prowled the Atlantic and opened the New World to Europe; and the English navy ensured that "the sun never set on the British empire."

As Alfred Thayer Mahan said in 1890 in his seminal work, *The Influence of Sea Power Upon History, 1600–1783,*

> The history of sea power is largely, though by no means solely, a narrative of contests between nations, of mutual rivalries, of violence frequently culminating in war. The profound influence of sea commerce upon the wealth and strength of countries was clearly seen long before the true principles which governed its growth and prosperity were detected. . . . Wars arising from other causes have been greatly modified in their conduct and issue by the control of the sea.

In the late 19th century, countries including the United States, Japan, Germany, and Great Britain embraced Mahan's vision. Navies began intensive shipbuilding programs that envisioned battle fleets with heavily armored ships, armed with large guns, at their core. The United States launched *Maine* in 1890 and *Texas* in 1892. The 1890s also saw the launching of *Fuji* by Japan, *Royal Sovereign* by Britain, and *Brandenburg* by Germany.

The rapid build-up of the world's navies was one symptom of a growing sense of imperialism in Europe, led in large part by Germany's Kaiser Wilhelm and a concern on the part of several countries over the enormous colonial empire of Britain. In the United States, Mahan and others strongly advocated for a much more aggressive US policy. For example, Mahan stated, "Whether they will or not, Americans must now begin to look outward. The growing production of the country demands it."

This philosophy, combined with the doctrine of sea power, led to the development of the US battle fleet. This fleet, formed around a core of massive battleships, served the country through World War I and the military buildup preceding World War II. However, after the Japanese attack on Pearl Harbor and the sinking of the British battleships *Prince of Wales* and *Repulse*, it became clear to most naval analysts that battleships were in the twilight of their careers. The halcyon days of the dreadnoughts of America's Great White Fleet, the British Grand Fleet, and

Germany's High Seas Fleet were coming to a close, as the era of aircraft carriers, nuclear weapons, and nuclear-powered submarines dawned.

So, we turn to USS *New Mexico* (BB-40). From her launching in April 1917 until her decommissioning in July 1946, *New Mexico* proudly flew the flag of the United States in war and in peace. Despite the decline of battleships as ship-against-ship weapons, prescient military minds such as Fleet Admiral Chester Nimitz and General of the Army Douglas MacArthur recognized that the formidable guns on battleships provided unsurpassed mobile shore bombardment platforms that were ideal for their island-hopping campaign against Japan. For that reason, *New Mexico* and her sister battleships were once again pressed into service.

In addition to her multiple awards for service during the war, *New Mexico* also holds the unique distinction of directly participating in the ceremonies ending both world wars. She escorted Pres. Woodrow Wilson to France for the Versailles Treaty negotiations that ended World War I, and she was present in Tokyo Bay when the instruments of surrender were signed aboard USS *Missouri* (BB-63) ending World War II.

So let's weigh the anchor, set the colors, and cruise through history on this amazing ship.

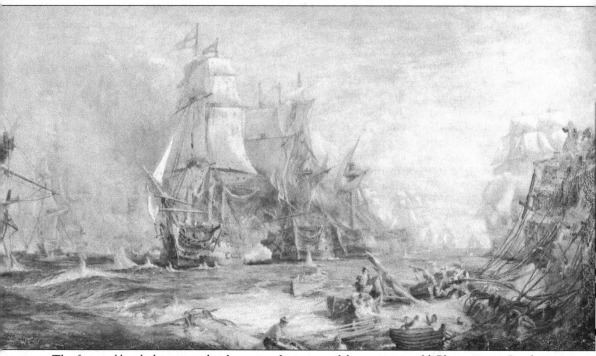

The first real battleships were the three-tiered triremes of the ancient world. Phoenicians, Greeks, and Persians developed multi-decked warships as early as the eighth century BC. Manned by hundreds of oarsmen, equipped with bronze rams, and carrying heavily armed boarding parties, the vessels could attain speeds of eight knots prior to ramming their enemies and boarding them, swords in hand. Naval analysts coined the term "battleship," originally "battleship of the line," in the late 18th century to describe the largest of the sailing warships commissioned by the great naval powers of the time. These ships relied on close broadside contact with the enemy. This image shows Adm. Lord Nelson's ship of the line HMS *Victory* at the Battle of Trafalgar on October 21, 1805. (Painting by William Lionel Wyllie, National Museum of the Royal Navy, Portsmouth, England.)

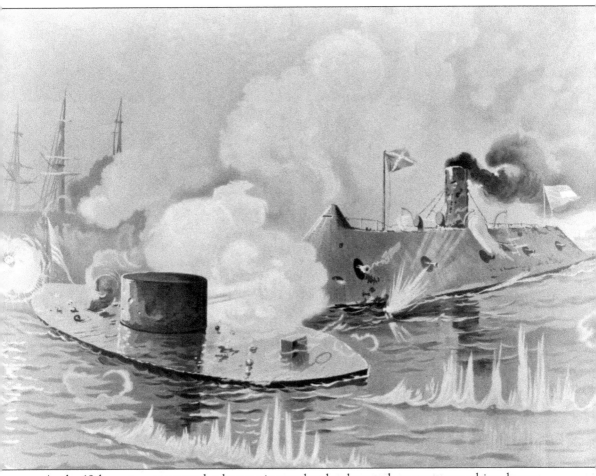

As the 19th century progressed, advances in naval technology such as steam propulsion, heavy armor plating, and guns in revolving turrets made sail-powered battleships increasingly obsolete. One of the proofs of these technological advances was the famous duel on March 9, 1862, between the Union *Monitor* and the Confederate *Merrimac* in Hampton Roads, Virginia, during the American Civil War. (Library of Congress.)

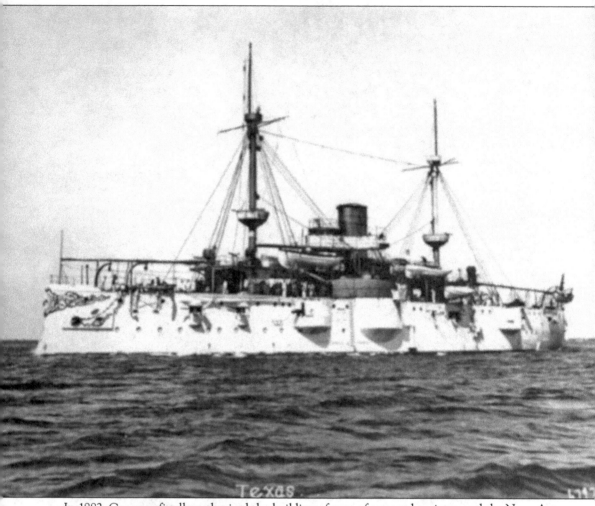

In 1882, Congress finally authorized the building of a set of armored cruisers, and the Navy Act of 1885 authorized the building of the first American battleships, USS *Texas* and USS *Maine*. These ships, classed as coastal battleships, displaced 6,700 tons, cruised at 18 knots, and carried large naval guns (12-inch on *Texas* and 10-inch on *Maine*). (USN.)

One

CASTLES OF STEEL

DAWN OF THE AGE OF BATTLESHIPS

For nearly a half century, from the beginning of the 20th century to the start of the Second World War, big-gun battleships were the ultimate weapon on the high seas. With guns ranging up to 18 inches in diameter accurately firing projectiles the weight of small cars to ranges of 35,000 yards while cruising at speeds up to 30 knots, these behemoths were the jewels in the crown of any navy's fleet.

With his unparalleled eloquence, First Lord of the Admiralty Winston Churchill described a sortie of the battleships of the British Grand Fleet from Portland, England, on August 20, 1914, as "scores of gigantic castles of steel wending their way across the misty shining sea like giants bowed in anxious thought."

USS *New Mexico* was one of these giants.

The US Navy, the once-proud service of John Paul Jones and *Bon Homme Richard*, Isaac Hull and "Old Ironsides," Stephen Decatur and the Barbary Pirates, and David "damn the torpedoes, full speed ahead" Farragut, had fallen on hard times after the Civil War. By 1881, the Navy was down from a postwar high of 51,000 men and 700 ships to 6,000 men and 48 ships. Congress refused to fund a naval reconstruction program, causing morale among the officers and sailors to drop to a new low.

The privateer *Virginius* was sunk and her crew executed in Cuba during the administration of Pres. Ulysses S. Grant. This led to final realization by the James Garfield administration that the United States was woefully ill-equipped to counter the increasing naval power of Great Britain, France, and Spain and to a renewed interest in naval capabilities.

The revolutionary theories of Adm. Alfred Thayer Mahan, who advocated the concept of a "battle fleet" rather than simply isolated battleships, impressed Pres. William McKinley and Assistant Secretary of the Navy Theodore Roosevelt. These new theories, a growing sense of American nationalism and imperialism, and the subsequent political support blossomed in the form of a battleship fleet and, eventually, in the building of USS *New Mexico*.

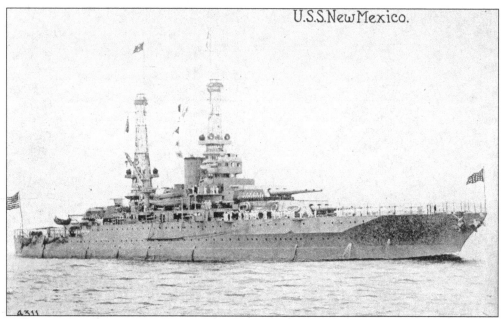

USS *New Mexico* began her life in the New York Naval Shipyard on October 14, 1915. On that day, her keel was laid down, marking the start of her construction. The top image shows her in her initial configuration with cage masts. The bottom image shows *New Mexico* at the end of World War II and near the end of her life. The venerable old battleship spent over 540 days in Pacific war zones, sustaining significant damage from two kamikaze attacks, including one that killed her commanding officer. She would eventually be sold for scrap in 1947. The remainder of this chapter sets the context for the decision to build *New Mexico* and the other members of the US battleship fleet. (Both, USN.)

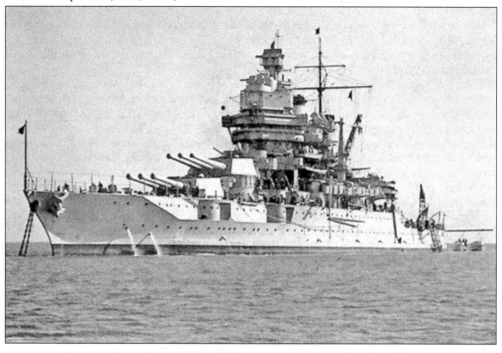

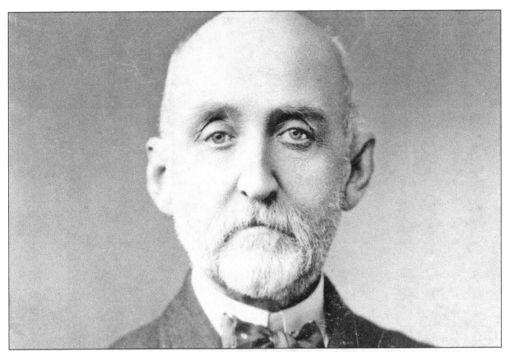

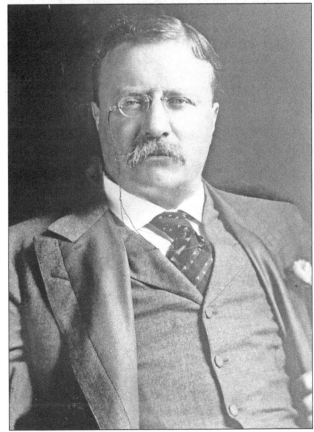

A combination of Adm. Alfred Thayer Mahan's (above) *The Influence of Sea Power Upon History, 1600–1783*, the 1898 sinking of the *Maine* in Havana, Cuba, and the subsequent extension of American Manifest Destiny to the Caribbean led to a strong refocusing of interest in the ability of the United States to project power overseas. Pres. Theodore Roosevelt (right), assistant secretary of the Navy at the start of the Spanish-American War, led the charge with his philosophy of "speak softly and carry a big stick." By the time his administration ended on March 4, 1909, the Panama Canal was under construction and powerful new dreadnought battleships such as USS *South Carolina* were being constructed or designed. Two of these battleships, USS *Wyoming* and USS *Arkansas*, would serve until the end of World War II. (Both, National Portrait Gallery.)

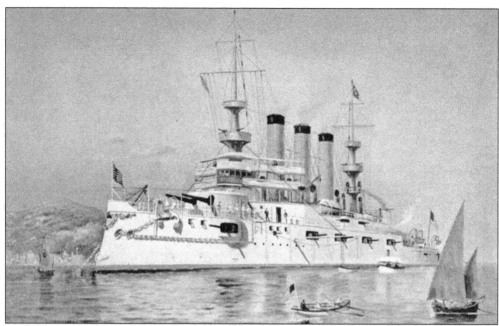

The battleship *Maine* (above) had been sent to Cuba to protect American interests during the Cuban war for independence from Spain. On February 15, 1898, the *Maine* sank in Havana harbor after a huge explosion (below). Two hundred fifty two American sailors lost their lives. The American press blamed the explosion on the Spanish and used it as justification to start the Spanish-American War. However, a 1974 analysis by a team assembled by Adm. Hyman Rickover, "Father of the Nuclear Navy" and an assistant engineer on *New Mexico* in the 1930s, suggested that the actual cause of the incident was an accidental coal dust explosion in one of the battleship's fuel bunkers. (Above, painting by Fred Pansing, Library of Congress; below, USN.)

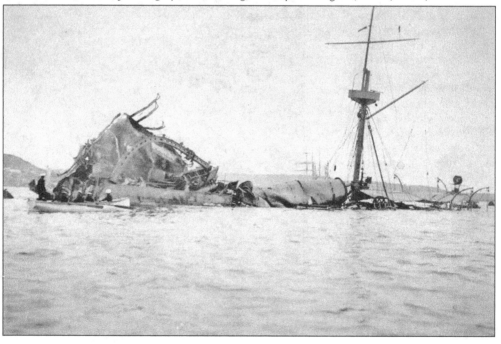

One of President Roosevelt's most famous accomplishments was the Great White Fleet, 16 battleships and assorted escorts that steamed over 42,000 miles from December 1907 to February 1909, showing the flag in ports around the world in a clear demonstration of US naval power. The Great White Fleet, shown above arriving in San Francisco on May 6, 1908, was enormously popular in the United States and helped to take the public's mind off the 1907 economic depression. As shown in the political cartoon below, this was a time of expansionist philosophy under Roosevelt, depicted on the bow of the lead ship. (Above, Naval Analysis Infographics, John Freeman; below, Alamy Photos.)

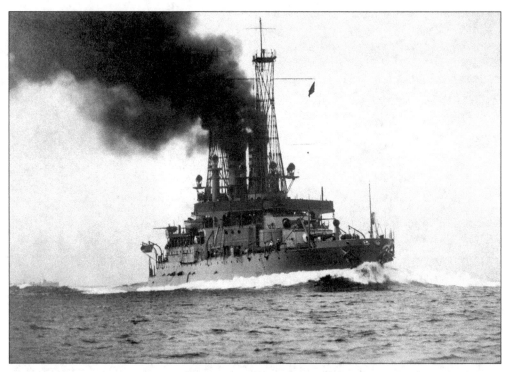

In the first decade of the 1900s, nations around the world continued to build ever more powerful military machines. In 1914, Winston Churchill, then Britain's first lord of the admiralty, remarked, "The world is arming as it has never armed before." The naval buildup in the United States continued under presidents William Howard Taft and Woodrow Wilson. As the world careened toward war, the Navy introduced ever-larger battleships. The South Carolina class (USS *Michigan* BB-27, above), commissioned in 1910, displaced 16,000 tons, carried eight 12-inch guns, and cruised at 18 knots. The New York class (BB-34 and BB-35, below), commissioned in 1914, displaced 27,000 tons, carried ten 14-inch guns, and cruised at 21 knots. (Both, USN.)

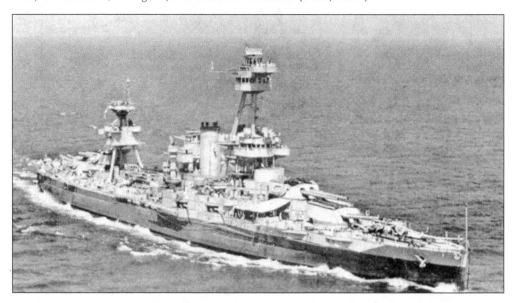

Two

New Mexico Goes to Sea
1917–1919

As American involvement in World War I approached, US Navy admirals carefully studied the rapidly evolving nature of naval warfare and adjusted their plans for future US battleships accordingly. The Nevada class was commissioned in 1916 with a displacement of 28,000 tons, ten 14-inch guns, and an increased armor belt. The Pennsylvania class, also commissioned in 1916, displaced 31,000 tons and carried twelve 14-inch guns.

In 1914, an act of Congress authorized the construction of BB-40. Originally slated to be named *California*, her name was changed to *New Mexico* because of a promise made to William Henry Andrews, the New Mexico territorial delegate to Congress, before New Mexico became a state in 1912. This renaming also allowed USS *California* (BB-44) to be built at the Mare Island Navy Yard in California.

In the early 20th century, the Navy's Bureau of Construction and Repair designed all American ships of the line. Naval architects, in close consultation with fleet commanders, developed specifications that were turned into basic designs. These basic designs were then submitted to a set of shipyard contractors who bid on the jobs. The contractors converted the Construction and Repair conceptual drawings into detailed drawings from which the ship was constructed. When this process had been completed for *California*, the keel was laid at the New York Naval Shipyard on October 14, 1915.

As authorized, *New Mexico* displaced 32,000 tons, carried twelve 14-inch guns, had a 13.5-inch armor belt, and cruised at 21 knots. She cost the US Navy $7.8 million, equivalent to about $146 million in today's dollars.

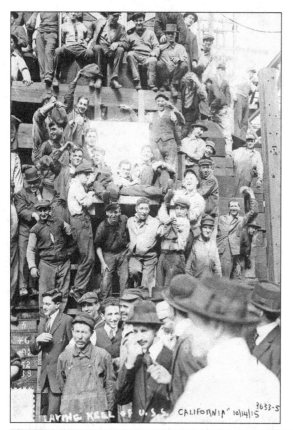

This image shows an elated set of shipyard workers celebrating the keel laying of USS *California* on October 14, 1915, at the New York Navy Yard. They will certainly have work for the next few years! Note the plaque in the center and the blocks that will support the hull as it is constructed. (Library of Congress.)

The name of BB-40 was changed to *New Mexico* shortly after the keel-laying, and the new battleship was launched at the New York Naval Shipyard with much fanfare on April 23, 1917. Franklin D. Roosevelt, then assistant secretary of the Navy, represented the US government at the ceremony. (*The New York Times.*)

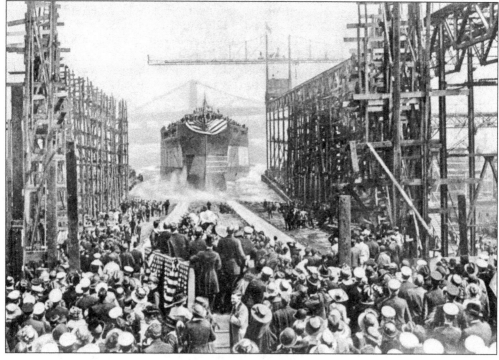

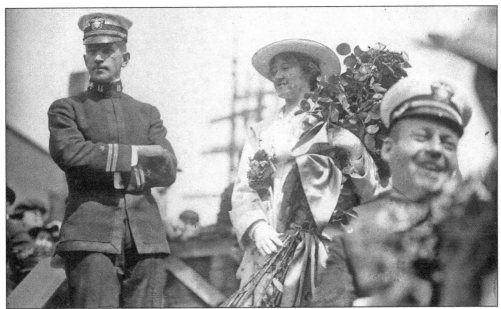

Margarita C. de Baca, 21-year-old daughter of former New Mexico governor Ezequiel Cabeza de Baca, represented the state at the launching ceremony. After she had broken the traditional bottle of champagne against the hull, Virginia Carr, granddaughter of a Civil War veteran and Medal of Honor recipient, threw a jug of water from the Rio Grande and Pecos against the ship as it started down the ways. (Richard Melzer.)

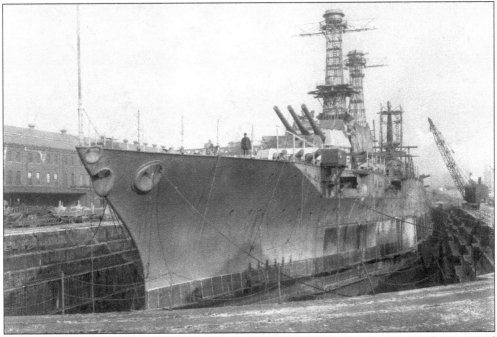

This image shows the port side of *New Mexico* in Dry Dock No. 4 at the New York Navy Yard on January 2, 1918. Note the extensive cabling draped over the side of the ship. Although both forward turrets and the cage masts have been installed, the bridge superstructure is still not on board. (USN.)

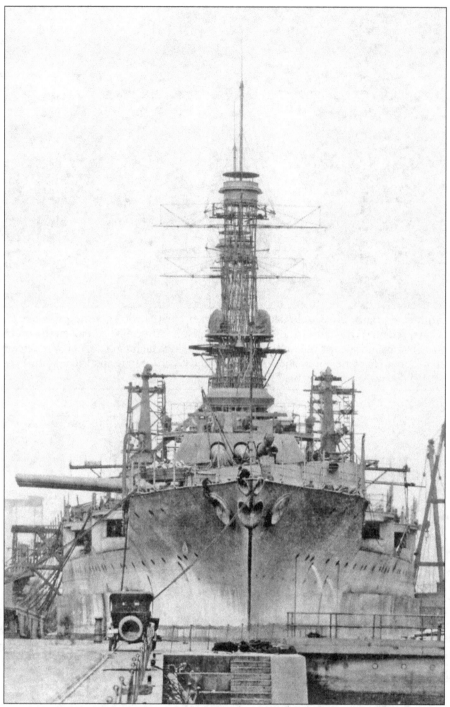

USS *New Mexico* is shown in the final fitting-out stage of construction. The openings along the main deck are awaiting the installation of the five-inch guns, and only one of the 14-inch guns in the forward turret has been installed. The water coming out of openings on the port bow suggests that some of the equipment that requires cooling was installed and operating. The Brooklyn Bridge can be seen through the fog in the background. (USN.)

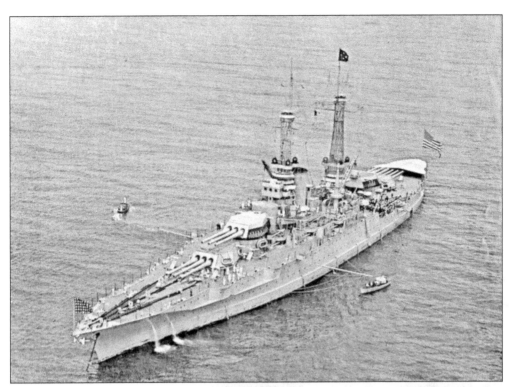

Commissioned on May 20, 1918, *New Mexico* was 624 feet long with a 98-foot beam, drew 30 feet of water, and displaced 32,000 tons. Her nine boilers and four shafts developed 32,000 horsepower and propelled her at a speed of 21 knots. Her main armament consisted of twelve 14-inch guns. A crew of 1,084 officers and men manned *New Mexico*, shown above at anchor in 1920. Capt. Ashley Herman Robertson (right), a Naval Academy graduate who had previously commanded the armored cruiser USS *San Diego* and was later promoted to vice admiral, served as her first commanding officer. (Above, USN; right, Library of Congress.)

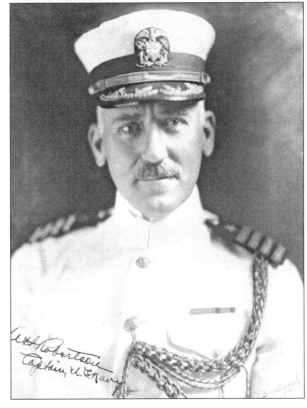

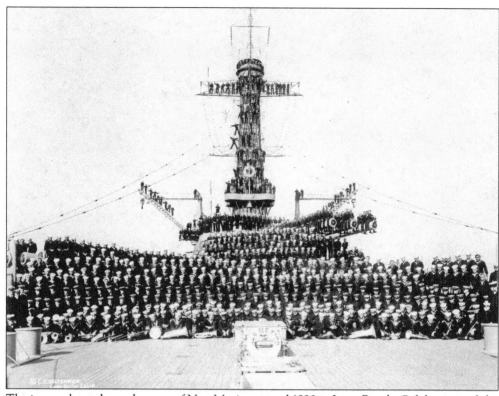

The image above shows the crew of *New Mexico* around 1920 in Long Beach, California, and the image below shows profile and overhead diagrams of the battleship at the time of her commissioning. The men are sitting on the deck, on the guns, on the bridge, and above the bridge. The scale drawing clearly shows the cage-type masts that were characteristic of early US battleships. The single funnel is behind the forward mast, and the crane for recovering the scout plane, as well as for loading heavy items, is situated amidships behind the funnel. The crane would later be relocated to the after deck. (Above, Library of Congress; below, Norman Friedman.)

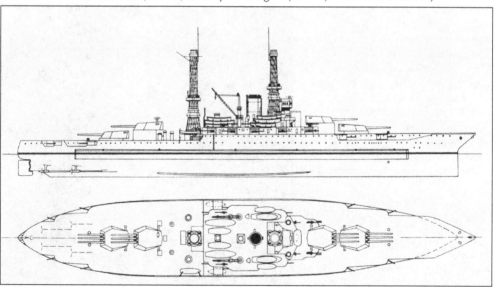

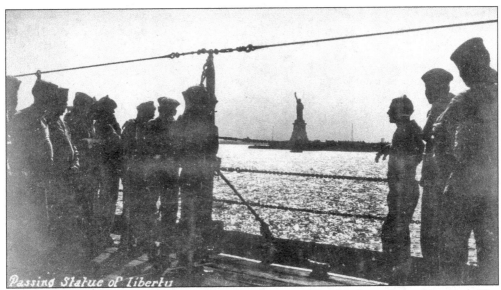

Passing Statue of Liberty

In late December 1918, not long after her commissioning, *New Mexico* sailed to New York City for a fleet review. The new battleship would participate in a number of these reviews over the coming years as she demonstrated America's continued determination to control her sea lines of communication. This iconic image shows the ship passing the Statue of Liberty in New York Harbor in 1918. (USN.)

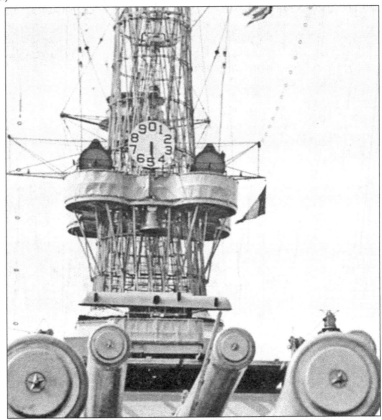

This view of the 14-inch turrets demonstrates the impressive firepower of *New Mexico*. The barrels of the guns have been capped to keep water out. Note one of the ship's bells, possibly the one now displayed on the campus of the University of New Mexico in Albuquerque, below the clock-like range indicator on the cage mast. (USN.)

One of *New Mexico's* earliest tasks was to escort USS *George Washington* (above) with Pres. Woodrow Wilson on board to France to meet with Georges Clemenceau, the prime minister of France, and David Lloyd George, the British prime minister, to negotiate the Treaty of Versailles at the end of World War I. The image below shows a liberty boat heading for Brest with a load of sailors ready to sample the good life in France. *New Mexico* also escorted the ship carrying the president back from the negotiations. During that return voyage, she encountered the schooner *Charlotte J. Sibley* out of Mystic, Connecticut, which was in distress. She rescued the crew and sank the derelict schooner with gunfire. (Both, USN.)

Three

THE WAY SHE WORKED

THE WONDER SHIP

Experience with earlier designs and observations of battleships of other nations led American naval architects to upgrade American battleships. A sleeker, more hydrodynamic clipper bow replaced the ram bow, armor plating was improved to protect against larger shells, splinter decks were installed to stop exploding ordnance from reaching critical components, and guns were improved to allow for longer ranges. *New Mexico* was also built with port and starboard torpedo tubes, which were later removed.

Propulsion was also upgraded. Newer, oil-fired boilers replaced older, coal-fired boilers. This not only simplified refueling and increased operational range but also removed the ever-present hazard of coal-dust explosions that had been a significant threat to naval vessels, including *Maine*, for decades. A turbo-electric drive system was also introduced, with USS *New Mexico* being the first battleship to have such an advanced propulsion system. Because of this, *New Mexico* was sometimes called "the wonder ship."

Every Navy ship is a complex and interconnected set of mechanical and electrical systems, and *New Mexico* was no exception. Not only did she have to be able to withstand the rigors of stormy ocean travel and the fury of enemy attacks from land, sea, and underwater, but she also had to provide for all the requirements of a small city of a thousand men. The crew needed to be fed, bathed, and berthed. Morale had to be maintained during long periods of nonmilitary activity, yet every man had to be ready to man a battle station at a moment's notice. Men had to be paid and mail had to be distributed. And every one of the thousands of pieces of equipment had to be carefully maintained.

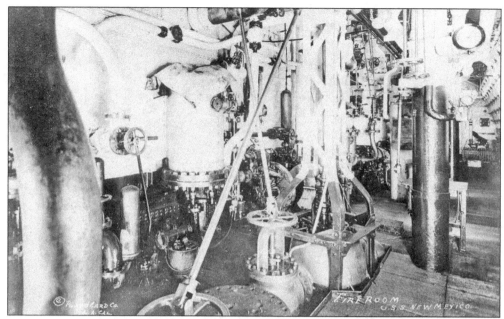

New Mexico used nine oil-fired boilers to produce steam to run the turbines for the two main generators. These, in turn, supplied electricity to the electric motors as well as to hundreds of additional pumps, compressors, motors, and other pieces of auxiliary equipment. This image shows a portion of one of the three boiler rooms on the battleship. (USN.)

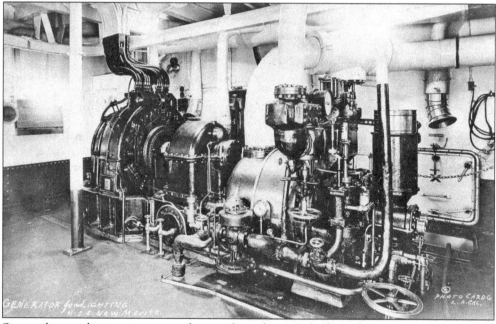

Six auxiliary turbine generators used steam from the main boiler system to power lighting and other electrical functions. The turbine is on the right, with the main and exhaust steam lines going into and out of the top of the unit. The 300-kilowatt generator is on the left with the electrical power lines leaving from the top of the unit. (USN.)

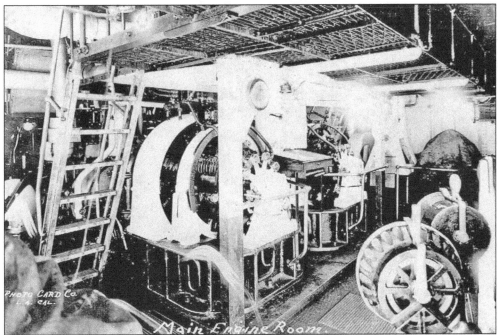

The nine oil-fired boilers
provided superheated
steam to two turbines,
each of which in turn
drove two electric
generators. The turbines
and generators were
located in the main
engine room of *New
Mexico* (above). These
generators drove the four
7,000-horsepower electric
motors, one of which
is shown at right, that
were directly connected
to each of the four
propeller shafts. This was
the first time the Navy
had installed a direct
electric drive system on a
battleship. (Both, USN.)

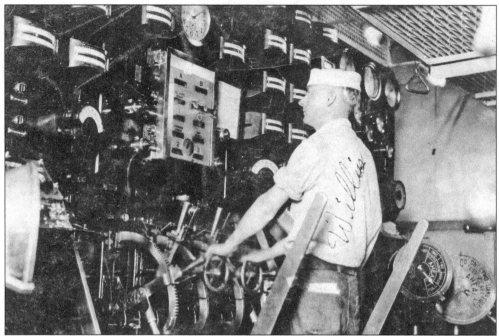

Operators controlled the electric motors from the panel shown above. As the electric motors drew more current, the turbines demanded more steam, and the fuel control valves for the boilers opened to provide it. Commands from the bridge were sent via an engine-order telegraph (below) to the engine room's repeater, visible just to the right of the operator above. One of the advantages of the electric drive system was an ability to maintain much steadier shaft revolutions per minute than corresponding direct drive systems. This enabled better ship control and seakeeping. In addition, the electric drive system was more fuel efficient than its direct drive counterparts. (Both, USN.)

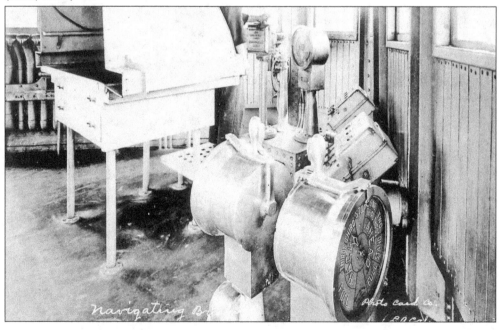

The first ship to use turbo-electric drive was the USS *Jupiter*, a coal carrier that was later converted to the Navy's first aircraft carrier (and renamed USS *Langley*). Building on *Jupiter*'s success, *New Mexico* was equipped with turbo-electric drive. William Le Roy Emmet designed the system and received the Thomas Edison medal in 1919 for its development. General Electric, the company responsible for the design and manufacture of the revolutionary electric drive system, was so proud of its product that it published a booklet on *New Mexico* and its new equipment (right). Below, General Electric president Edwin W. Rice (fourth from left, wearing glasses) presents a painting to Secretary of the Navy Josephus Daniels (beside painting, behind girl). Also present was US Navy Engineer-in-Chief, Rear Admiral Robert S. Griffin (third from left, white beard). The others are unidentified. (Right, General Electric Company; below, Greg Trapp.)

The Electric Ship

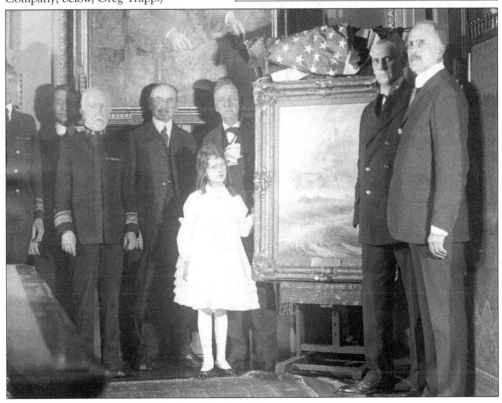

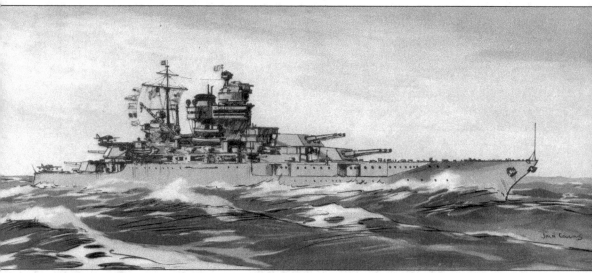

After 13 years, the Navy's Bureau of Ships decided to replace the turbo-electric drive system with a more conventional direct-drive system made by the Curtis Company. This type of propulsion unit used superheated steam directly from the boilers to drive the propulsion turbines, one for each of the four shafts, instead of using the electric motor system. The direct drive system was more powerful per ton of machinery than the turbo-electric system, although it used substantially more fuel per mile traveled. However, the potential for a single point of failure, should the centralized switchgear in the turbo-electric system be damaged under battle conditions, made the direct drive more attractive. This modification was completed during the 1931–1933 overhaul at the Philadelphia Naval Shipyard. The *New Mexico* is pictured shortly after completion of this overhaul. (Dick Brown.)

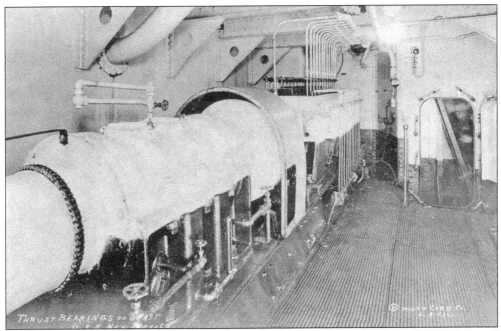

The electric motors (and, after the 1931–1933 overhaul, the turbine-driven geared motors) turned four large shafts that turned the propellers. This image shows one of these shafts. The large piece of equipment in the middle is one of the journal bearings supporting the shaft. (USN.)

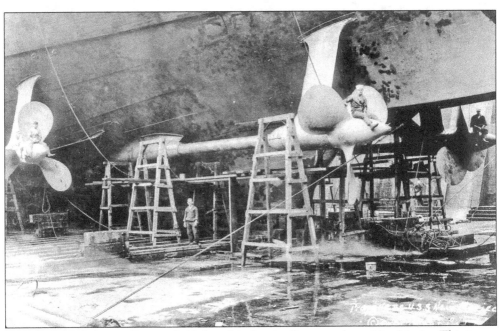

Four three-bladed propellers, each 13 feet, 6 inches in diameter, drove *New Mexico*. This image shows the external shaft, propeller, and rudder configuration. Early American battleships, including *New Mexico*, had a single rudder, operated by two rams. Some European battleships and later US battleships had dual rudders to provide additional control and redundancy. (USN.)

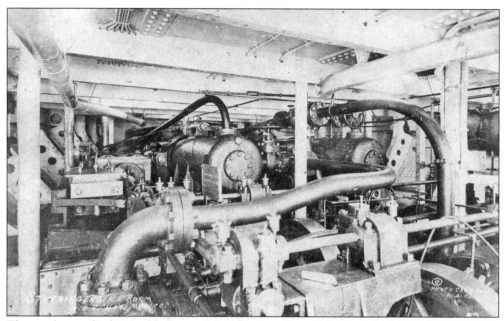

The two large cylinders in the center of this image are the rudder rams, which moved the rudder in response to signals from the helm on the bridge. The rudder rams were moved using hydraulic pressure. The hydraulic pumps for the rudder system were electric, powered from the ship's main electrical system. (USN.)

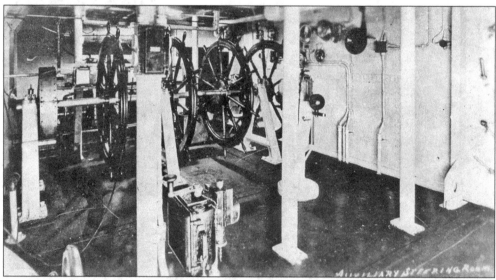

Redundancy is a key characteristic of warships. They must be able to sustain damage and keep on fighting. The auxiliary steering compartment is an example of this redundancy. Should the ability to steer the ship from the main helm on the bridge be disrupted, the ship could be steered from this compartment, deep in the engineering spaces. The compartment was routinely manned during battle stations. (USN.)

Battleships were equipped with powerful 36-inch searchlights that fulfilled a number of functions. They were used to spot and illuminate incoming aircraft, for search and rescue operations, and they were also used, particularly in World War I, to help fend off night attacks by destroyers. During daylight hours, destroyers were vulnerable to the battleship's secondary batteries, but at night they could rush in and fire their torpedoes much more effectively. This was a particular problem during the Battle of Jutland in 1916. In that pivotal engagement, searchlights were used to illuminate the incoming vessels and blind their gunners. (Both, USN.)

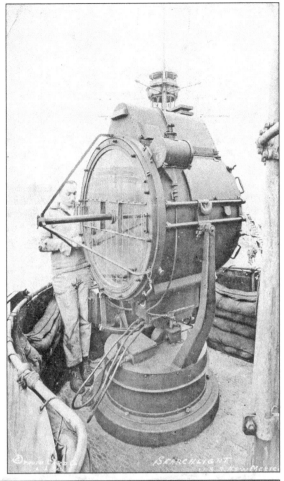

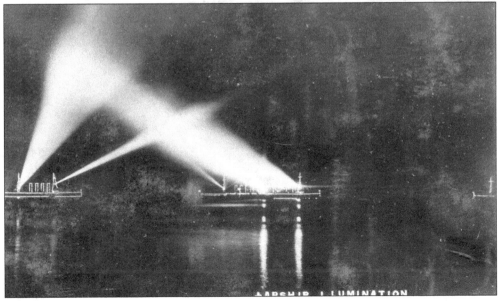

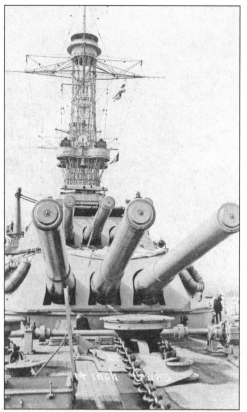

New Mexico's main armament consisted of four turrets, each containing three 14-inch guns (left). Each gun barrel was just over 58 feet long, nearly six feet longer than the guns on earlier battleships. These massive naval rifles fired 1,400-pound projectiles to a maximum range of 37,000 yards. The guns could fire two rounds per minute and had a muzzle velocity of 2,800 feet per second. *New Mexico* was also the first American battleship to use a three-gun turret design, which allowed each of the guns in the turret to be aimed independently. The cross-sectional diagram below is for a 16-inch gun turret but is representative of the components and functional elements of the 14-inch guns on *New Mexico*. The powder and projectiles were transported from magazines below decks to the turret itself using electrical lift systems. (Both, USN.)

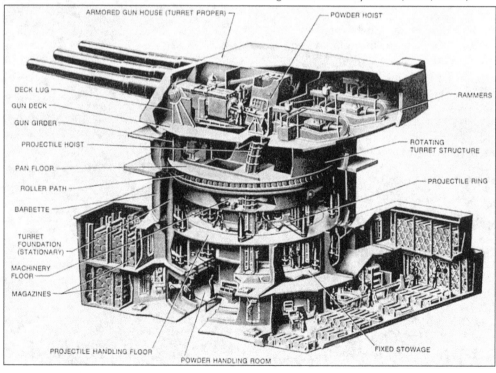

ARMORED GUN HOUSE (TURRET PROPER) — POWDER HOIST

DECK LUG — RAMMERS
GUN DECK
GUN GIRDER
PROJECTILE HOIST — ROTATING TURRET STRUCTURE
PAN FLOOR
ROLLER PATH — PROJECTILE RING
BARBETTE
TURRET FOUNDATION (STATIONARY)
MACHINERY FLOOR
MAGAZINES

PROJECTILE HANDLING FLOOR — FIXED STOWAGE
POWDER HANDLING ROOM

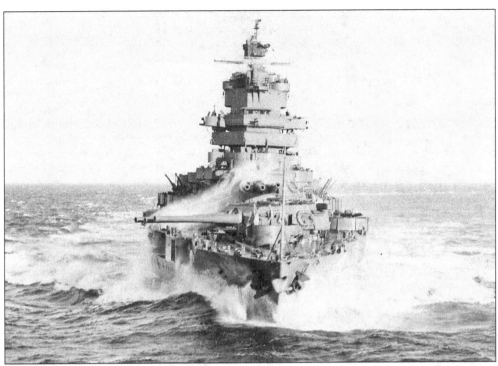

Before the days of radar, the range to either ship or land targets for the main batteries was obtained using an optical rangefinder. This device (the long projecting object between the two parts of the superstructure in the image above) used lenses to merge images from the two ends of the rangefinder into a single image. When the operator had obtained a single, unblurred image by adjusting the lenses, he could read the range to the target from a set of dials in front of him. The image below shows a sailor using a rangefinder on USS *Texas* (BB-35). (Both, USN.)

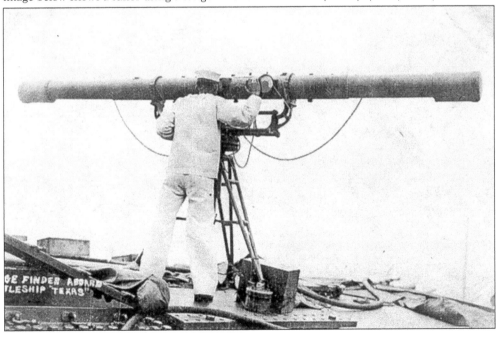

GE FINDER ABOARD
TLESHIP TEXAS"

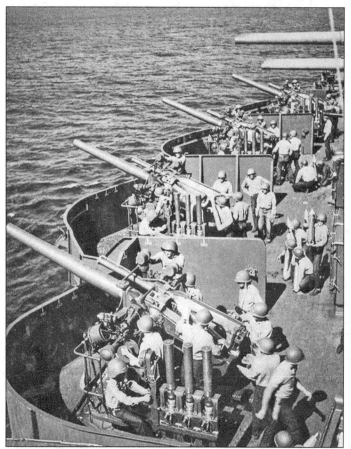

New Mexico's secondary batteries originally consisted of both three- and five-inch weapons. During the 1931–1933 overhaul, the three-inch systems were replaced with five-inch guns designed for close-in bombardment, for ship-to-ship engagements with smaller warships such as destroyers and torpedo boats, and for antiaircraft fire. The image at left shows four of the five-inch guns on *New Mexico* during shore bombardment at Saipan in June 1944. As the threat from aircraft became more of a concern, smaller antiaircraft guns such as the 40-millimeter Bofors guns, which could put up a more rapid rate of fire, were also added. They are shown below in dual and quad mounts. (Both, USN.)

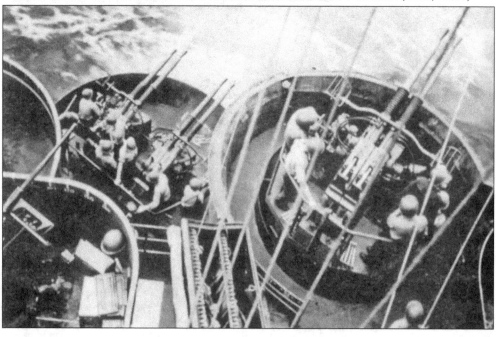

Four

THE INTERWAR PERIOD
1919–1941

While many people believed (and everyone hoped) that the carnage of World War I would not be repeated, others recognized that many of the underlying issues that had led to the worldwide conflagration had not been resolved. Germany chafed under the oppressive restrictions of the Treaty of Versailles, Japan challenged the United States for supremacy in the Pacific, and the world was headed for economic collapse in 1929. US politicians once again raised the image of the Great White Fleet as a means of demonstrating American power and resolve. *New Mexico* played a key role in this demonstration of power by showing the flag around the globe, going south to Chile, cruising throughout the Caribbean, and visiting Australia and New Zealand in the strategic South Pacific.

As a result of her extensive time at sea and improvements in naval technology, the battleship spent a good deal of time in various shipyards, upgrading her capabilities and performing much-needed maintenance in the interwar period. One of these shipyard periods was a major overhaul from 1931 to 1933, replacing almost her entire engineering plant and upgrading her armor and armament. By the time she emerged from the Philadelphia Naval Shipyard in 1933, she was virtually a new battleship, ready to take on the challenges that were looming on the horizon.

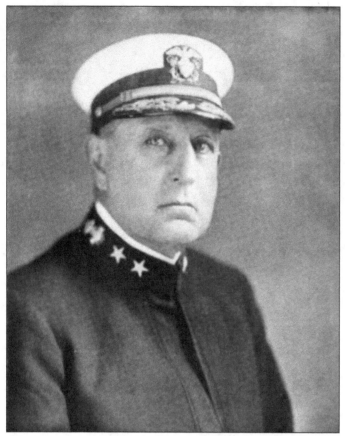

In 1921, as flagship of the US Pacific Fleet under the command of Adm. Hugh Rodman (left), *New Mexico* led several ships from the fleet on a 6,000-mile "show the flag" cruise down the west coast of South America to Valparaiso, Chile. As the Japanese navy became more of a force in the Pacific, US naval strategists recognized the strategic importance of the countries of South and Central America, particularly those along the Pacific Ocean, as potential refueling and resupplying locations. The image below shows *New Mexico* with the submarine *S-7* (SS-112) on March 21, 1921, in Pearl Harbor, Hawaii. (Both, USN.)

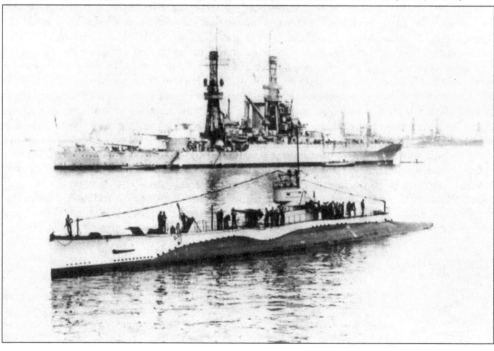

The southwestern Pacific was of even more strategic importance to the United States. Japan relied on this area for critical supplies, including oil for its growing navy. Australia and New Zealand, both members of the British Commonwealth, were strong allies of the United States. Their location and port cities were viewed as logical jumping-off points for any conflict in the western Pacific. In 1924, *New Mexico* led a US fleet to Australia and New Zealand. The image above shows the welcoming party of Australian dignitaries in Sydney awaiting the arrival of officers from *New Mexico*, and the image below shows Honolulu, a waypoint for any trip to the South Pacific. (Both, USN.)

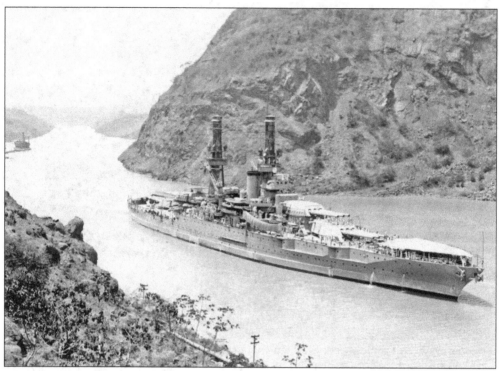

New Mexico passed through the Panama Canal on many occasions during her lifetime. Theodore Roosevelt planned the Panama Canal's locks to be large enough to allow safe transit of American battleships. (Recall that *New Mexico* had a 98-foot beam.) The image above shows the *New Mexico* passing through the Culebra Cut in 1924, and the image below is of the dual Pedro Miguel locks. Note the train in the right background and the second battleship entering the left lock in the bottom image. (Both, Richard Melzer.)

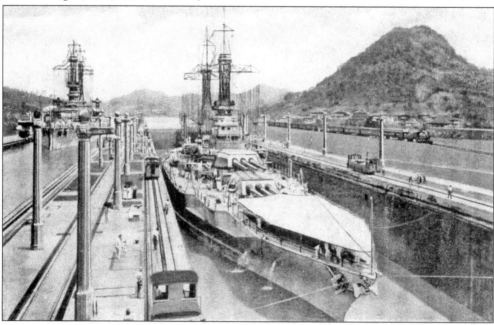

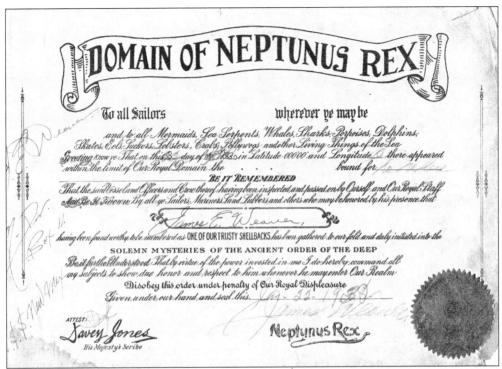

In the course of her cruises to Chile and the South Pacific, *New Mexico* crossed the equator. Crossing the equator has long been a time of initiation for sailors in navies throughout the world. Although the time-honored traditions may differ from ship to ship and from navy to navy, there is a general form—King Neptune is a prominent figure, as is Davy Jones. Other characters often appear, including a surgeon, a barber, men dressed as bears, and a judge. These roles are all played by "shellbacks"—those who have gone through the ritual before. First-time participants are known as "pollywogs." (Both, Richard Melzer.)

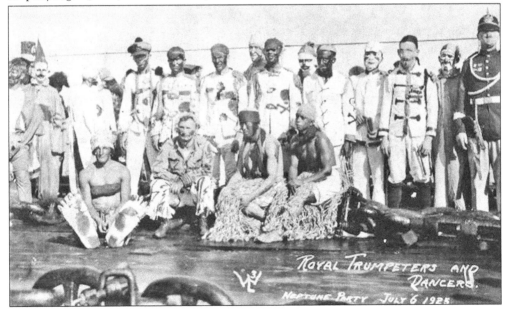

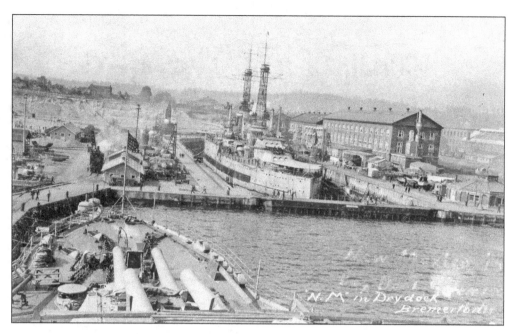

After the 6,000-mile cruise down the coast of South America in 1921 and the transpacific cruise to Australia and New Zealand in 1924, the battleship came back through the Panama Canal and headed north to New York City. Leaving New York, *New Mexico* sailed south to the Caribbean, then traversed the Panama Canal yet again, returning to the Pacific Fleet. Once in the Pacific, she turned north to Bremerton, Washington, and entered the Puget Sound Naval Shipyard for a much-needed upkeep and overhaul (both images). She left Bremerton in April 1925 and proceeded to Hawaii, where she participated in fleet training exercises. (Both, USN.)

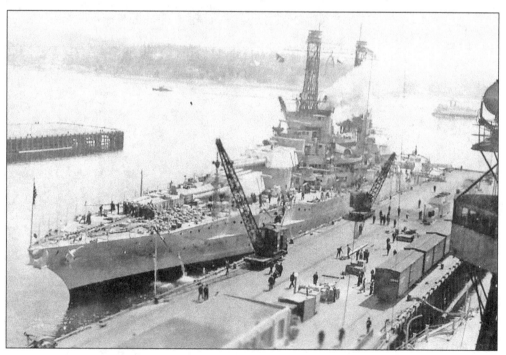

These two images show *New Mexico* undergoing overhaul and maintenance at the Hunter's Point Naval Shipyard in San Francisco in the late 1920s. This shipyard, located at Portrero Point, was established in 1870 and was run by the Union Iron Works before being sold to the Bethlehem Shipbuilding Company in the early 20th century. The image at right shows the ship tied up alongside the pier, and the image below shows the ship in one of the Hunter's Point dry docks. Both can be dated to before 1930, because the cage masts are still installed. (Both, USN.)

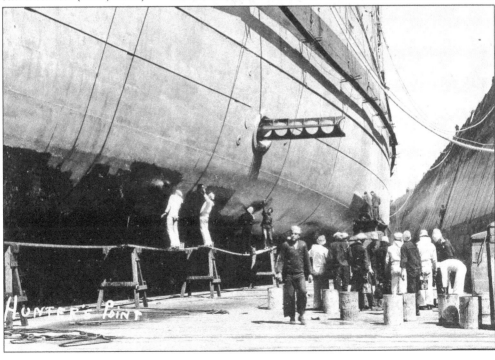

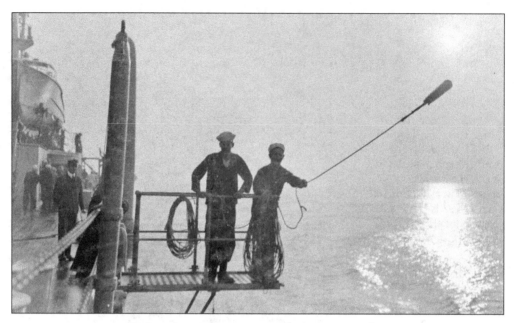

Maintaining a fixed routine was important aboard ship. This kept operations orderly and on time and provided a structure for the crew as it performed its work. Above, a quartermaster is taking a sounding to ensure that the depth of water beneath the ship is sufficient. In the days before fathometers, physical soundings were a part of the daily routine. Below, mess cooks are standing topside for inspection. Note the shine on the pails and the clean white uniforms. The chief petty officer at the far end of the line appears to have found something that may need correcting! (Both, USN.)

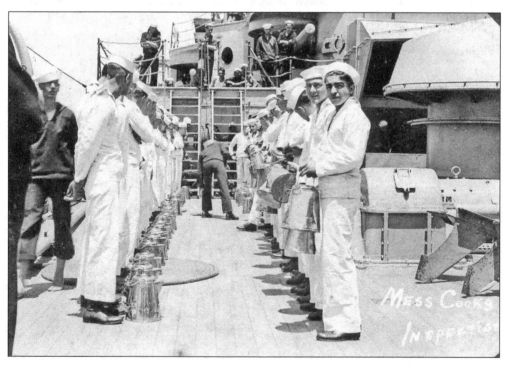

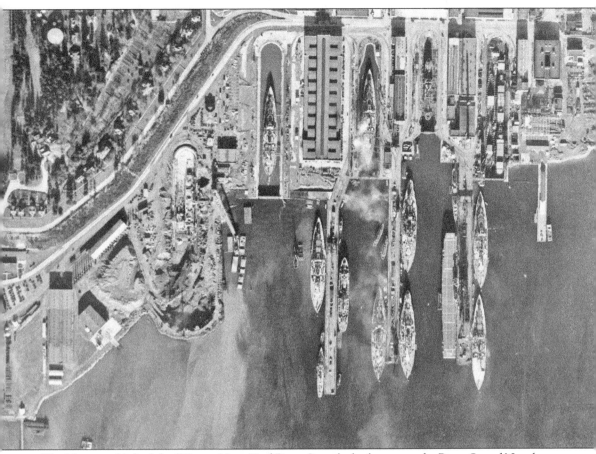

The Navy established the 179-acre Navy Yard Puget Sound, also known as the Puget Sound Naval Shipyard and the Bremerton Navy Yard, in Bremerton, Washington, in 1891. During World War I, the Navy Yard constructed many classes of vessels, including submarines and submarine chasers, minesweepers, tugs, and other auxiliaries. During World War II, the shipyard repaired battle damage to ships of the line. *New Mexico*, as a part of the Pacific Fleet, spent a year at Puget Sound from 1924 to 1925 and several months in 1943 and 1944. This aerial view shows the shipyard in 1940 at nearly full capacity, with six cruisers, an aircraft carrier, and a destroyer on the refit piers and several ships in the dry docks, some flooded down and some pumped dry. (USN.)

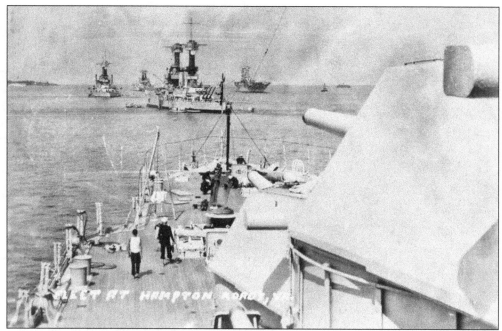

Hampton Roads, Virginia, has a naval history dating to the middle of the 18th century. The famous battle of ironclads occurred here in 1862. In this 1930 image, *New Mexico* leads a fleet of battleships into Hampton Roads (the term "roads" is short for "roadstead," an archaic term meaning a sheltered location where ships can safely ride at anchor) prior to going into an extensive three-year overhaul at the Philadelphia Naval Shipyard. (USN.)

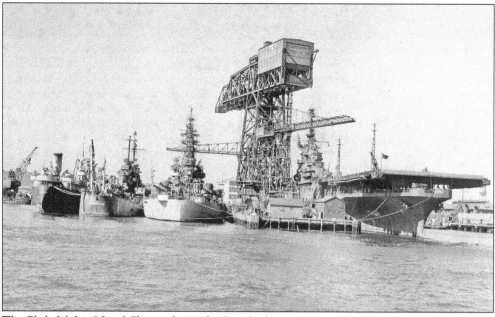

The Philadelphia Naval Shipyard was the first facility of its kind in the United States, having been started in 1776. This image shows the shipyard in 1945. The iconic 350-ton League Island Hammerhead Crane weighed 3,500 tons and was, for a time, the world's largest crane. Even after larger ones were built elsewhere, it remained for many years the US Navy's largest crane. (USN.)

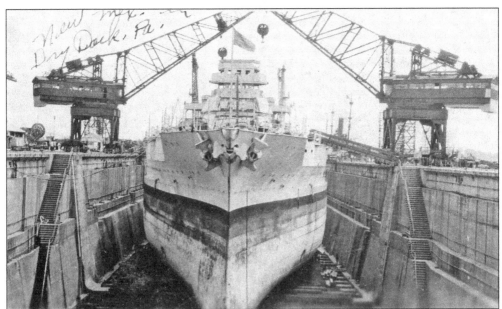

The overhaul and modernization in Philadelphia included replacing the nine original boilers with six newer models, replacing the turbo-electric drive with direct turbine drive, removing the cage masts, installing a modern superstructure, and adding torpedo blisters (external bulges on the hull that provided a barrier between the hull and incoming torpedoes). In addition, the three-inch guns were replaced with more five-inch guns, and more armored decking was added. The image above shows *New Mexico* dry docked in the Philadelphia shipyard in 1931. The image at right shows the removal of one of the ship's iconic cage masts. (Both, USN.)

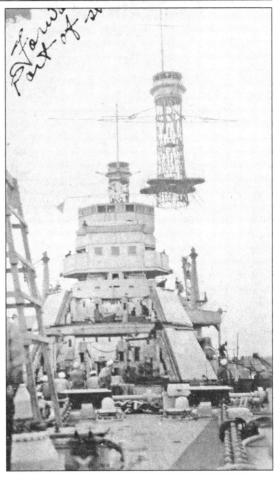

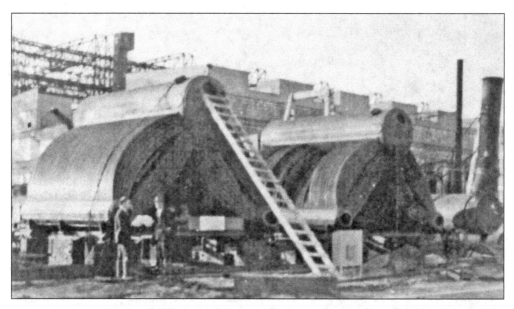

Replacement of the boilers was an important operation during the Philadelphia overhaul. The image above shows two of the six new boilers on the dock in Philadelphia, waiting to be installed. Access to the engineering spaces to permit removal and reinstallation of boilers and changing the entire propulsion equipment required that equipment such as gun turrets be removed and decks be cut away. Because of the complexity of piping and wiring in the ship, these types of modifications required extreme skill and planning on the part of shipyard engineers. The image below shows *New Mexico* near the end of her two-year overhaul. (Both, USN.)

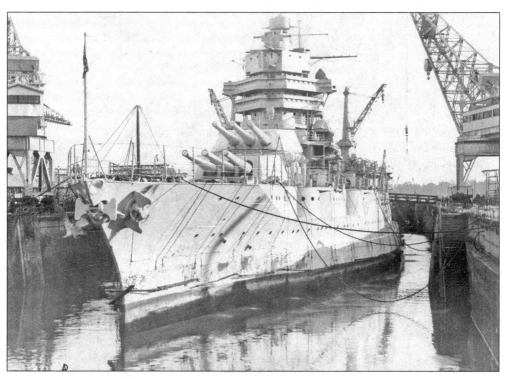

Several fleet reviews occurred during the interwar period. These events were typically held for high-ranking officials from Washington, DC, frequently in conjunction with major anniversaries such as Navy Day. They showcased the nation's navy to the rest of the world, bolstered the morale of the ships' crews, and showed the nation the power and might of the US Navy. The image above shows *New Mexico* and several other battleships anchored off San Pedro, California, in preparation for a fleet review prior to her 1931 overhaul. The image below shows another such review off the California coast in 1939 with aircraft overhead. (Both, USN.)

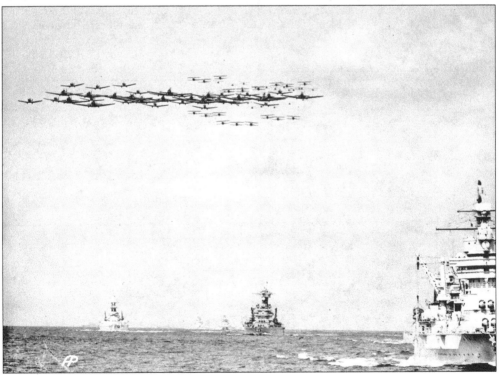

The image at left shows the battleships *New Mexico*, *Idaho*, *Mississippi*, and *California* arriving in Norfolk on April 12, 1939, for a fleet review by Secretary of the Navy Claude A. Swanson. *Idaho* and *Mississippi* were the other two members of the New Mexico class of US battleships. Recall that *New Mexico* herself had originally been designated as *California*, but that the name had been changed after the keel laying. *California* (BB-44) was a member of the Tennessee class and was launched in 1921. The image below is a naval cover from *New Mexico* showing the signatures of several of its officers. The cover was posted on Armistice Day 1935. (Left, USN; below, Richard Melzer.)

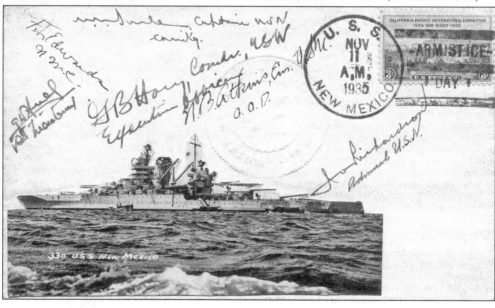

Five

LIFE ABOARD THE QUEEN
MUCH WORK AND SOME PLAY

Life aboard any Navy vessel is a combination of training, cleaning, routine upkeep, standing watch, sleeping, and more training. Life aboard USS *New Mexico* was no exception. Much of this came to be routine, especially during the years from commissioning to the pre–World War II period. Cleaning and painting were constant requirements, following the Navy adages "Work it may, shine it must, and may it never, ever rust" and "If it moves, salute it; if it doesn't move, paint it!"

Shortly after her commissioning, *New Mexico* demonstrated her excellence in engineering, gunnery, and battle efficiency. In the 1920s, she won several coveted "meatball" awards for her performance against other battleships. She was also awarded an "E" for excellence, which she proudly had painted on her stack. Perhaps because of her superlative performance or because of her innovative electric motor drive system, she acquired the nickname "the Queen," a moniker that remained with her for the rest of her service.

Patrolling the North Atlantic after 1939, when the German navy had resumed its policy of unrestricted submarine warfare, meant that considerable time was spent maintaining full battle readiness, with the men at general quarters for hours at a time. This became even more a part of daily life when *New Mexico* deployed to the Pacific Fleet in the aftermath of the Pearl Harbor attack. From battle readiness, the crew transitioned to actually fighting, principally shore bombardment and antiaircraft fire.

Despite the challenges of operating a battleship, there were also moments of levity—athletic events, music, movies, and liberty in exotic ports from the Caribbean to the South Pacific. Entertainment was as essential for morale as good food and letters from home.

Although nearly 10,000 men served on *New Mexico* during the three decades of her active duty operations, one man, Fireman James Weaven, has been chosen here to represent the crew. Serving from the late 1920s through the early 1930s, Weaven captured much of the life and times of shipboard duty in his leather-bound cruise book. His very personal images give an opportunity to see what daily life was like aboard the Queen before World War II. Two informative books also provide details about life on board using interviews with members of the ship's crew: *USS New Mexico (BB-40): The Queen's Story in the Words of Her Men* by John Driscoll and *All the Queen's Men* by John Wickland. (Richard Melzer.)

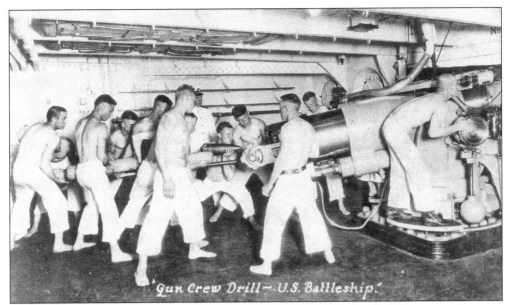

Training was one of the constants of life aboard a battleship. Crews trained for operations such as navigation, maintaining station, and refueling at sea, and they trained for battle. The image above shows a gun crew training on one of the five-inch guns. The temperature inside the metal turret could be oppressively hot, particularly when the ship was operating in the tropics, so the men typically went shirtless. Although it might seem unusual that they were barefooted, shoes moving across a metal deck could build up a static charge that could cause a premature detonation of the powder charges. The image below shows crewmen working at a number of routine tasks amidships. (Above, USN; below, Richard Melzer.)

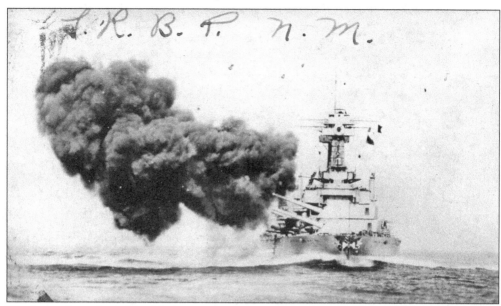

The image above shows *New Mexico* practice-firing its 14-inch batteries. Battleships needed to take care in firing their big guns, because the shock and muzzle blast could damage other components on the ship. This mass salvo would send nearly eight and one half tons of metal hurtling toward the enemy. The image below shows sailors loading the 1,400-pound projectiles for the big guns. Although the loading process had elevators to take the projectiles down to the ammunition storage area, there was a lot of manhandling involved to get the shells to and from the elevators. Because these projectiles cost almost as much as a Cadillac, one old salt on *New Mexico* would always say, "There goes another new Cadillac!" (Both, USN.)

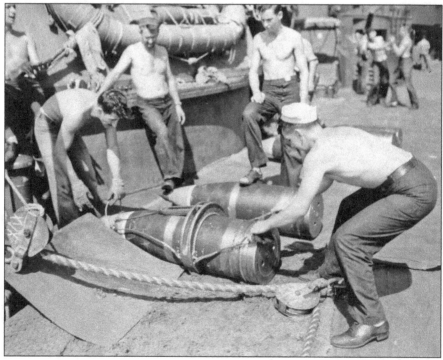

The training and practice clearly paid off. *New Mexico* won the coveted "meatball" award for the first time under Capt. A.L. Willard and several other times during the 1920s, including three consecutive years (a Navy record) from 1928 to 1930. She also won the gunnery award. Shown above is Commander Pryor, the executive officer, admiring the award plaque in 1931. Winning these awards meant that the ship could wear the efficiency "E" on her stack, and the crew was entitled to wear a dark blue ribbon with a metal E and gold edging on their uniforms. (Both, USN.)

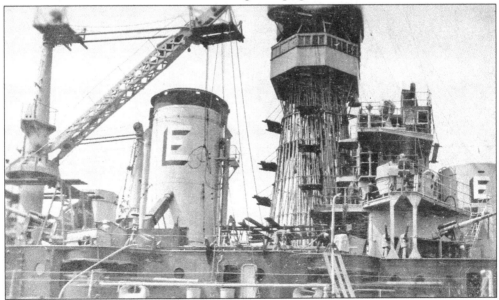

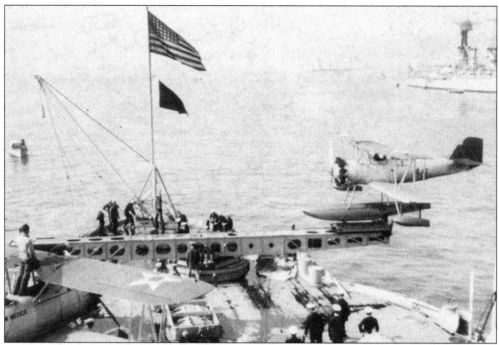

Most battleships carried seaplanes. They were used to scout for enemy vessels, to spot targets for the big guns, and to assist in search and rescue operations. The seaplanes were launched from catapults but were not designed to land on the deck of the ship, so special procedures were developed to recover them alongside using cranes (originally located amidships and later near the stern of the ship). The crew constantly practiced launching and recovering the scouting planes while underway. These images show seaplane launching and recovery operations. (Both, USN.)

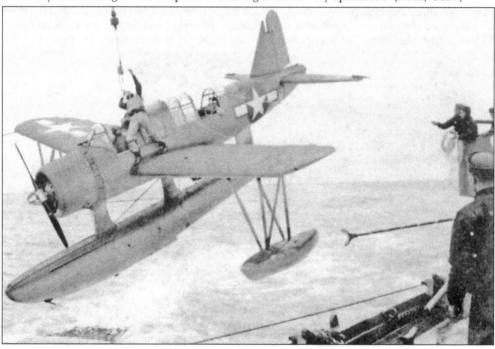

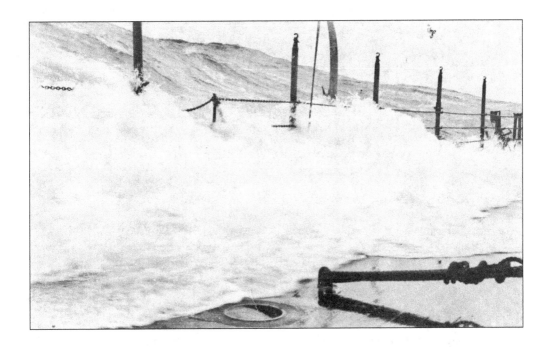

New Mexico was an enormous vessel. She drew over 30 feet between the waterline and the keel and had an additional 20 or so feet of freeboard from the waterline to the main deck. These images show the vessel underway in heavy seas. Note that the waves are breaking over the deck and, in the bottom image, the bow is actually underwater, meaning that the waves are probably 50 to 60 feet in height. While not in danger of capsizing or being swamped, the crew had quite a ride when sailing or fighting under these conditions. (Both, Nancy Tucker.)

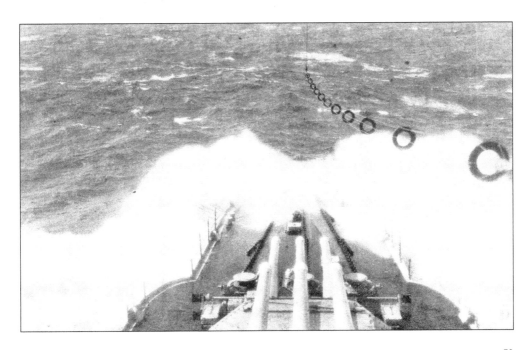

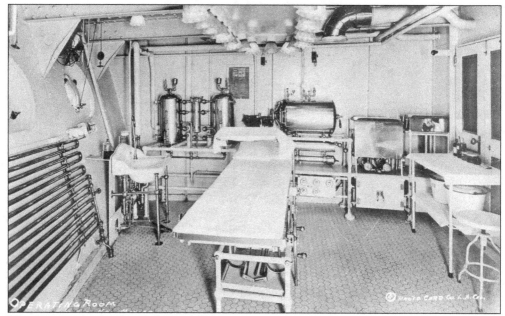

Warships are designed to fight, and fighting inevitably produces casualties. *New Mexico* had a full medical staff and fully equipped facilities such as the operating room shown above in 1919. Medical personnel were prepared to deal with everything from minor illnesses and on-the-job accidents to life-threatening illnesses, serious injuries, and battle casualties. Because smaller vessels did not have the medical capability of the larger battleship, sick or injured men were occasionally transferred to *New Mexico* for treatment while both vessels were underway. The image below shows a destroyer alongside *New Mexico* transferring a sick or wounded sailor to the battleship for treatment. (Both, USN.)

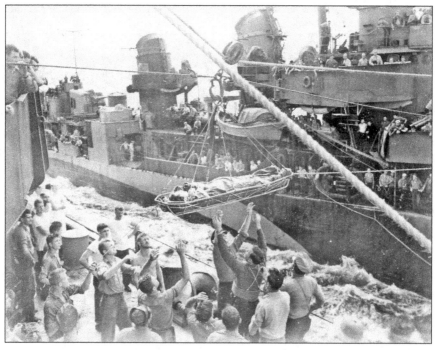

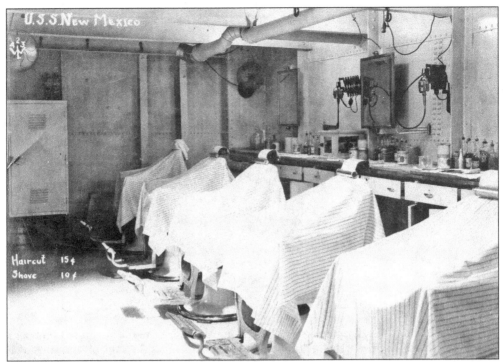

New Mexico had a five-chair barbershop (above) and a full laundry (below). Despite the often dirty work of operating and maintaining a battleship, officers and crew were expected to maintain acceptable levels of cleanliness at all times. With a crew of over 1,000, keeping uniforms cleaned and pressed was an around-the-clock job. Officers and enlisted men had laundry bags that were sent to the laundry. In the case of senior officers, preferences for starch were included! Of course, during combat, barbers and laundrymen were assigned to battle stations, where they were full participants in the ship's primary mission. (Both, USN.)

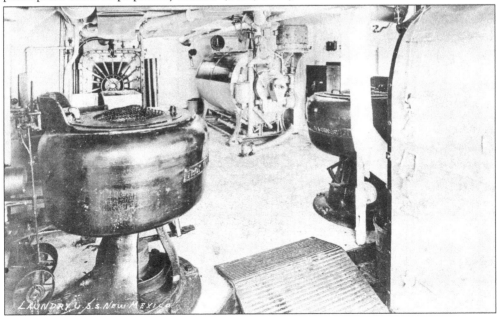

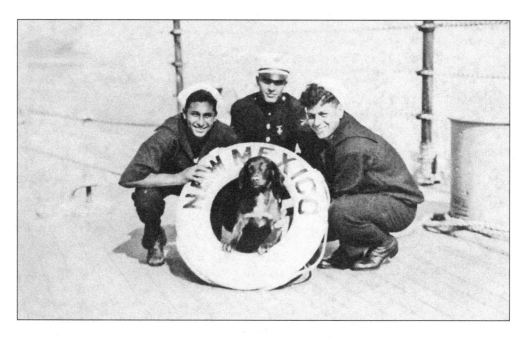

Many ships had mascots, although, strictly speaking, animals were not permitted on board. Because of the importance of morale to the smooth functioning of the ship, officers frequently looked the other way when an animal "appeared." During their 1925 Australia cruise, the crew adopted a dog named Sydney (above). For a time during World War II, the ship had a female cat named Kwajalein after the Pacific atoll (wearing a life vest below). Unfortunately, Kwajalein went AWOL (absent without leave), allegedly because of a friendly tomcat she met in Australia in 1944. (All, USN.)

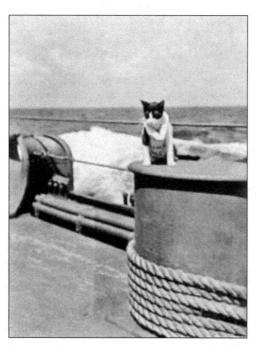
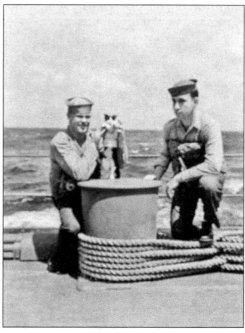

Life aboard ship was mentally and physically strenuous and challenging. During wartime, the crew was frequently at battle stations for days at a time. Even in peacetime, the rigors of constant maintenance and training took their toll. Officers worked hard to create opportunities to reduce tension, provide diversions, and build morale. Onboard competitions between divisions and departments were one way to accomplish these goals. Above, sailors engage in a potato race on the deck. Below, representatives from various departments try their hand at line climbing on the big guns. (Both, USN.)

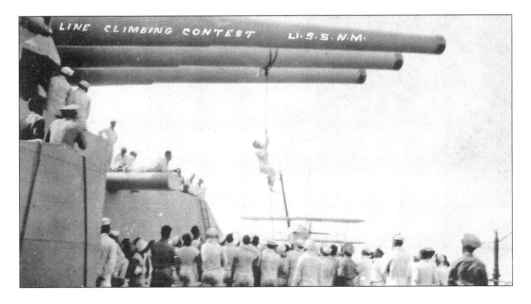

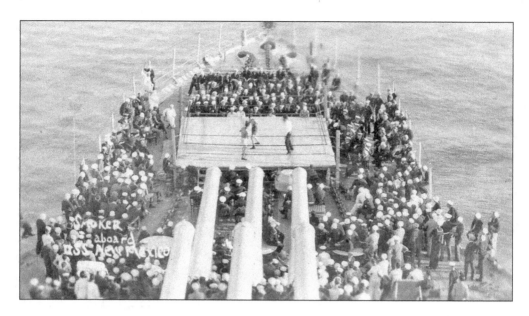

Boxing, baseball, and rowing were three of the most popular sports in the country during the middle of the 20th century. Life aboard *New Mexico* reflected the popularity of these sports and others. Contests were frequently arranged between departments on board or between teams from different ships when in port. Above, a boxing ring has been set up on the forward deck. Although liberty boats were no longer rowed to shore, rowing was maintained as a competitive event. The image below shows the winning rowing team from a 1927 competition in Los Angeles. (Both, USN.)

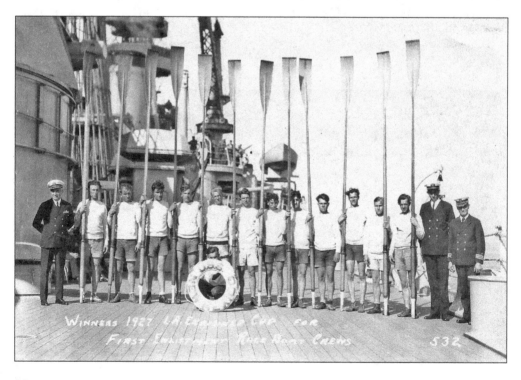

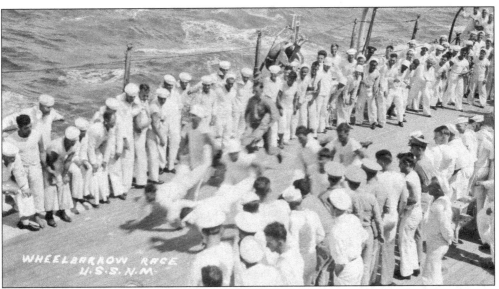

WHEELBARROW RACE
U.S.S. N.M.

Wheelbarrow races were popular, providing quite a challenge at sea while the ship was underway because the balance of the participants was even more precarious as they raced down the deck. Running on the rough deck on their hands and falling on their elbows must have led to lots of scrapes and bruises for the participants. (USN.)

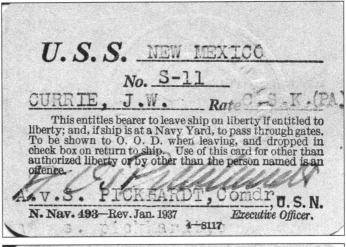

U.S.S. NEW MEXICO

No. S-11

CURRIE, J.W. Rate C.S.K.(PA)

This entitles bearer to leave ship on liberty if entitled to liberty; and, if ship is at a Navy Yard, to pass through gates. To be shown to O. O. D. when leaving, and dropped in check box on return to ship. Use of this card for other than authorized liberty or by other than the person named is an offence.

A. v. S. PICKHARDT, Comdr, U. S. N.

N. Nav. 493—Rev. Jan. 1937 *Executive Officer.*

4—8117

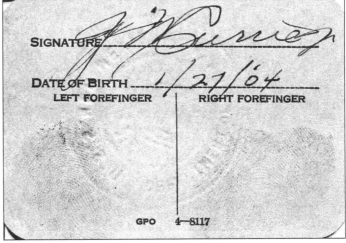

SIGNATURE

DATE OF BIRTH _____ 1/27/04

LEFT FOREFINGER RIGHT FOREFINGER

GPO 4—8117

All the games in the world could not substitute for going ashore on liberty. These two images show the front and back of the liberty card (a standard means of identification) for J.W. Currie, one of the ship's storekeepers. Note that his fingerprints are provided in case of a run-in with local or military law enforcement. (Both, Richard Melzer.)

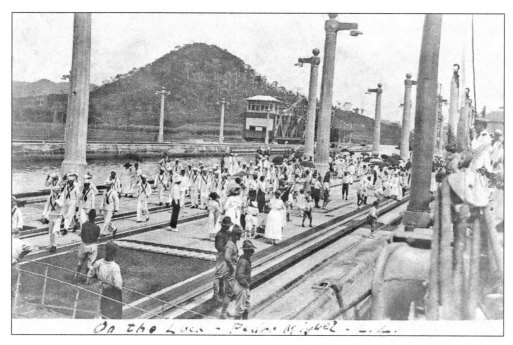

On the Lock - Pedro Miguel - C.Z.

New Mexico spent time between the wars training and "showing the flag" throughout the Pacific and the Caribbean. Moving back and forth between the oceans necessitated several passages through the Panama Canal. During these passages, there were opportunities for the crew to go ashore. Above, sailors leave the ship for some fun times in the Panama Canal Zone. The islands of the Caribbean also provided opportunities for sailors to leave their "castle of steel" and see some of the sights and sample the local culture. The image below shows a sailor strolling past some of the local residents while on liberty in Barbados, British West Indies, in 1930. (Above, USN; below, Richard Melzer.)

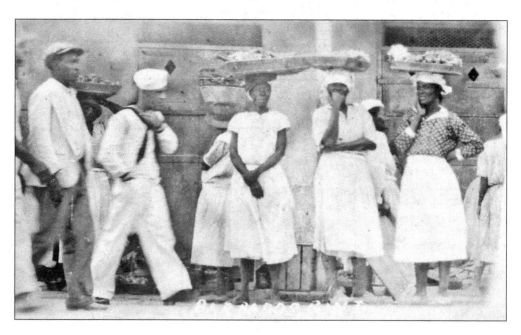

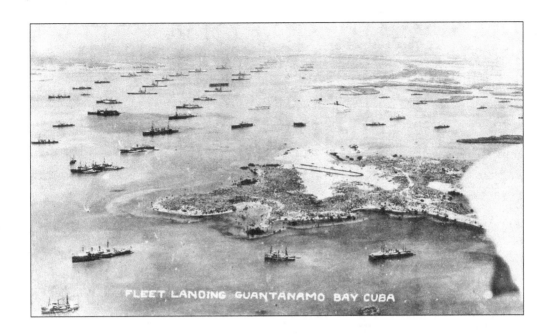

The Shore Patrol always faced the challenge of managing the sailors who had gone ashore after long deployments. When the whole fleet was in, as at Guantanamo Bay, Cuba, around 1930 (above), the Shore Patrol must have had its hands full. This is suggested in the cartoon below from *New Mexico's* pre–World War II newspaper, the *Salvo*. There are nearly 50 ships visible in the image above. This must have made the Cuban barkeepers ecstatic, but when liberty was over, the local jails and the brigs on many of the ships would probably have been filled to overflowing. (Above, USN; below, Richard Melzer.)

Enjoying—
"Good old Stuff"
Panama

WHAT! YOU UP HERE AGAIN? HOW DO YOU ACCOUNT FOR THIS?

WELL YOU KNOW HOW UT ISH CAP'N' WHEN YOU'VE AD A BIT TOO MUTCH

Every sailor anxiously anticipated going ashore on liberty. Since the only alcohol onboard was in the sick bay and used for "medicinal purposes," sailors from *New Mexico* looked forward to having a drink in one of the many bars that populated the waterfront such as the one above in Panama. (Richard Melzer.)

Liberty after weeks at sea could be both a blessing and a curse. Imbibing a bit too much and then returning to the ship might lead to a special visit with the captain at a non-judicial hearing called "captain's mast." Punishment for this sort of infraction could range from restriction to the ship to reduction in rank. (Richard Melzer.)

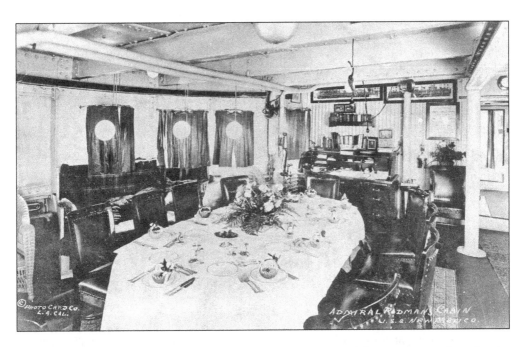

The Navy has always been a very rank-conscious organization. From the most senior admiral to the most junior seaman, everyone knows his place. And some places on board are nicer than others! The photograph above shows the admiral's and captain's dining room on *New Mexico* in 1919, and the image below shows the wardroom (officers' dining room). With an admiral embarked, the fleet staff conducted considerable planning in his quarters, necessitating a conference table. While the wardroom was large enough to have the entire officer corps (between 50 and 60 men) sitting down together, there would always be some men on watch, some ashore or on leave, and others unavailable for meals at the proscribed times. (Both, USN.)

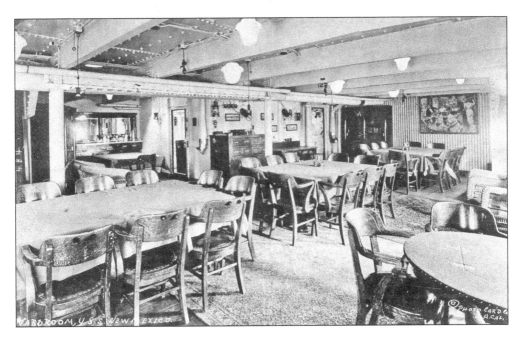

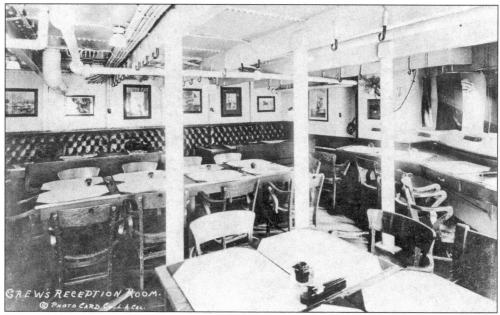

CREW'S RECEPTION ROOM.
© PHOTO CARD CO. L.A. CAL.

Compare the image above of the crew reception room with the images of the admiral's quarters and the wardroom on the previous page. Once again, the old adage of "rank hath its privileges" is manifest. Below, sailors assigned to galley duty, known as mess cooks, have prepared the crew's mess for an inspection. One of the ship's cooks reported that the kitchen used 1,600 pounds of potatoes, 1,000 pounds of flour, 700 pounds of sugar, 600 pounds of canned milk, 720 dozen eggs, and 300 pounds of coffee daily. In addition, the crew would eat 1,026 pounds of ham, 1,350 pounds of chicken, or 1,400 pounds of turkey when those entrees were served. (Both, USN.)

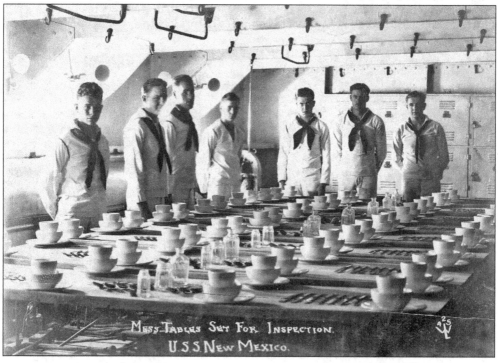

MESS TABLES SET FOR INSPECTION.
U.S.S. NEW MEXICO.

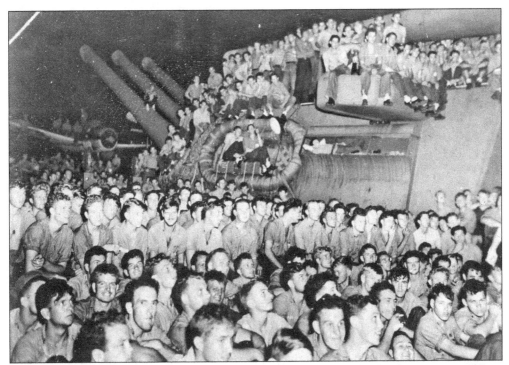

Movies came of age at about the time *New Mexico* first took to sea, and they became a major form of recreation aboard ship. By the outbreak of World War II, they provided prime entertainment. Movies such as *Casablanca*, with Humphrey Bogart, and almost any movie with an actress such as Ava Gardner were hugely popular. Hollywood was encouraged to provide movies to the armed forces as a morale booster in support of the war effort. Here, the crew of *New Mexico* watches a movie on the after deck. (USN.)

From her commissioning until about 1940, the crew slept in hammocks hung from hooks throughout the ship. When the sailors awoke, they rolled up and secured their hammocks with "six marlin hitches and one round turn." During some periods when there were extra men aboard, as one man left a hammock, another would slide in, a process known as "hot bunking." After 1940, cots replaced hammocks on most Navy ships. (USN.)

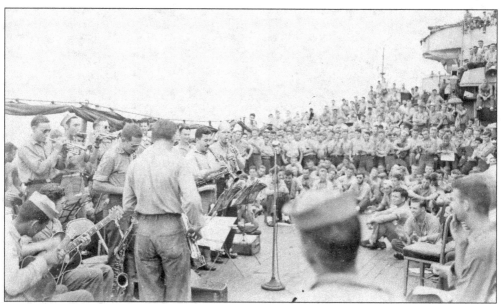

The first half of the 20th century was a boom time for music in America. Almost every home had a radio, and many also had pianos or guitars, so boys from rural America grew up singing and playing instruments. Jazz and big bands were all the rage, and music became another means of passing the time aboard ship. Many of the sailors were talented musicians, and the ship actually had assigned bandsmen. The image above shows a performance on deck, while the image below shows some sailors getting together to sing to the accompaniment of a ukulele. From the expressions on their faces, this tune was probably of the bawdier variety. (Both, USN.)

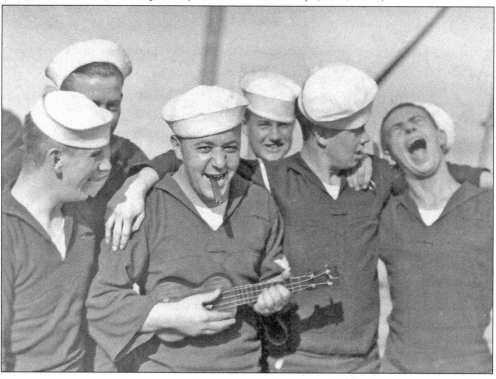

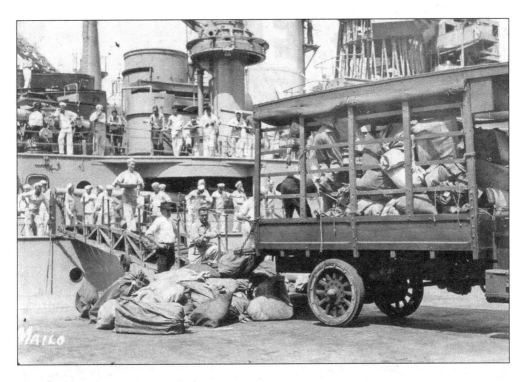

Mail call and payday were two of the most important events aboard ship. The image above shows a mail truck being unloading with bags of mail and crew members waiting anxiously to see if they have heard from a loved one this time. Although undated, this image is clearly from before 1931, because the cage masts are still evident in the background. The image below shows the disbursing officers going through the pay records by hand for each sailor. The days of automatic deposit and Excel spreadsheets for maintaining financial records were still many decades in the future. (Both, USN.)

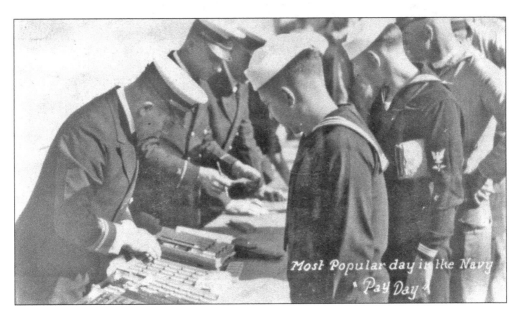

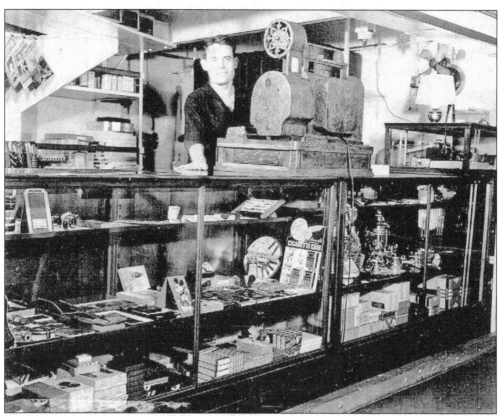

The ship's store was always a popular place. Storekeeper First Class Bob Thompson reported that in one week, he sold 35,000 packs of cigarettes (15,000 of which were Lucky Strikes). In one month, he sold 1,000 packs of razor blades, 1,200 tubes of toothpaste, 1,400 toothbrushes, 17,000 boxes of matches, and 20,000 bars of soap. The ship's store also stocked packets of official photographs that crew members could purchase for use in assembling cruise scrapbooks. (USN.)

Two things remained foremost in every sailor's mind during long deployments at sea—women and women! Married men pined for the girl they left behind, and single men dreamed of the women they might meet at the next port. Shown here is one of James Weaven's special sweethearts. One of the crewmen sent a letter to a friend in North Carolina writing, "You should be here to help me with these well-tanned girls." (Richard Melzer.)

Of course, all young, red-blooded American males ogled at the likes of Ava Gardner (right). In fact, almost every issue of the onboard World War II newspaper, the *Queen's Daily*, had a pin-up picture of some iconic actress in a seductive pose. In addition, the paper frequently included cartoons that promoted activities, such as the sale of war bonds, using seductive women. In today's world, this sort of publication would be deemed politically incorrect, but during the war, pin-ups were a major morale booster for soldiers and sailors around the world. (All, Greg Trapp.)

"I TRUST YOU'VE BEEN SAVING MORE THAN JUST YOUR WAR BONDS FOR ME!"

"YOU'LL BE HAPPIER IF YOU HOLD ON TO THEM."

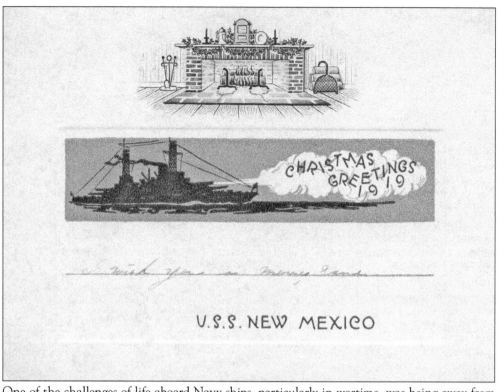

U.S.S. NEW MEXICO

One of the challenges of life aboard Navy ships, particularly in wartime, was being away from family and loved ones during the holiday seasons. This is a Christmas card printed onboard *New Mexico* and made available to officers and crew during the 1919 season. (Richard Melzer.)

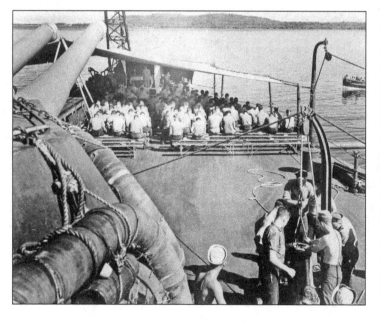

Wine, women, and song were not all that occupied the sailors' minds. They knew that they were going "in harm's way," and many of them had friends or shipmates who would not come home again. This image illustrates the classic expression "Praise the Lord, but pass the ammunition." While some of the crew attend religious services on the after deck, others are loading ammunition for the 14-inch guns. (USN.)

Six

A Date Which Will Live in Infamy

December 7, 1941

Sunday, December 7, 1941, dawned overcast and calm in Honolulu, Hawaii. A light sea breeze ruffled the flags of the battleships tied up along Battleship Row. Wisps of smoke drifted from the ships' funnels, while sailors assigned to in-port duty polished fittings and swabbed decks. Many men were enjoying liberty in Honolulu.

Suddenly, hundreds of Japanese planes roared over Diamond Head, drawing a bead on the ships anchored and tied up alongside in Pearl Harbor. The fate of the world would change in just a few minutes.

Adm. Isoroku Yamamoto had planned the attack on Pearl Harbor but is reputed to have worried that it would "awaken a sleeping giant and fill him with a terrible resolve." Through a program of clandestine departures and radio silence, his carrier-based aircraft had managed to achieve complete surprise. On the other hand, all the US aircraft carriers were at sea, and the submarine base and critical petroleum tank farm with fuel for the entire Pacific Fleet were left undamaged. Yamamoto's prediction was fulfilled—the sleeping giant had been awakened, and his critical war-fighting capabilities were far from destroyed.

On December 7, 1941, *New Mexico* was performing convoy escort duty in the Atlantic. She was immediately ordered to head west through the Panama Canal and join the Pacific Fleet. Initially, she went to San Francisco and San Pedro, California. Then, after a short visit to Hawaii, she entered Puget Sound Naval Shipyard in Bremerton, Washington, for an overhaul that included adding additional antiaircraft guns to her already-impressive batteries.

Following the overhaul, *New Mexico* was assigned to escort duty in the South Pacific and then returned to Pearl Harbor to prepare for a campaign against the Japanese occupation of the Aleutian Islands in the North Pacific. She would be engaged in several critical battles in the Pacific campaign and would remain in the thick of the fight up to Japan's surrender in 1945.

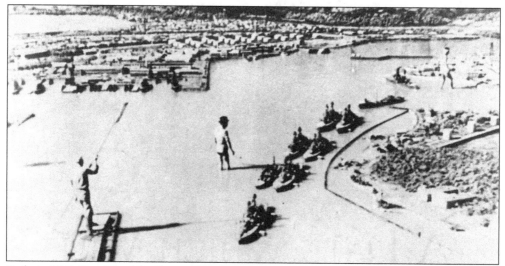

Early in 1941, Pres. Franklin Roosevelt had moved elements of one of the most powerful navies in the world from San Diego to Pearl Harbor. The Japanese Imperial High Command decided to preempt the Americans by launching an attack on the US Navy's newest prime facility in the Pacific. The image above shows a scale model of Pearl Harbor used by the Japanese to plan the attack. (USN.)

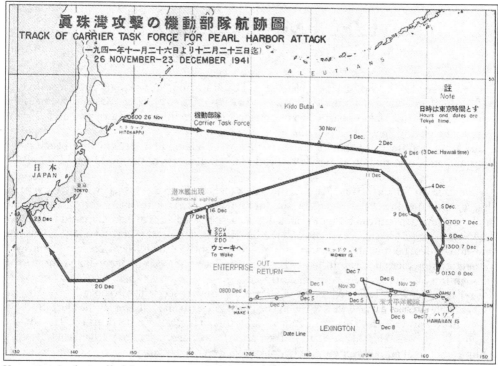

Yamamoto's plan called for a carrier task force under Adm. Chuichi Nagumo to sail east under radio silence. They would rendezvous at a position 200 miles north of the Hawaiian Islands. The Japanese ambassador was supposed to deliver a message to the US government breaking diplomatic relations prior to the launching of the aircraft, but the ambassador was delayed, so the attack occurred without a state of war existing. (Library of Congress.)

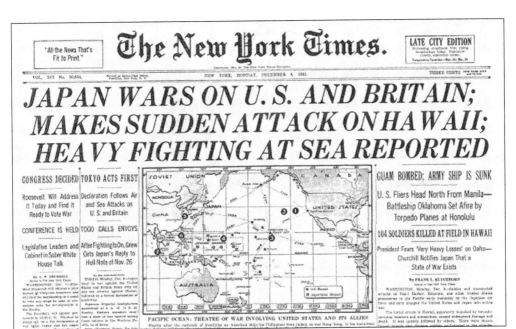

The Pearl Harbor attack, coupled with its apparently devious nature, outraged the American people. The uproar was intense and predictable. On December 8, 1941, Pres. Franklin Roosevelt gave his famous "Date of Infamy" speech to a joint session of Congress (below), and within an hour, Congress had passed, and Roosevelt had signed, a declaration of war. Admiral Yamamoto knew the American psyche and had been concerned that such a reaction would occur. He feared that, once aroused, the American war machine would ultimately destroy Japan. Yamamoto eventually came to regard the Pearl Harbor attack as a serious blunder. (Above, *The New York Times*; below, Library of Congress.)

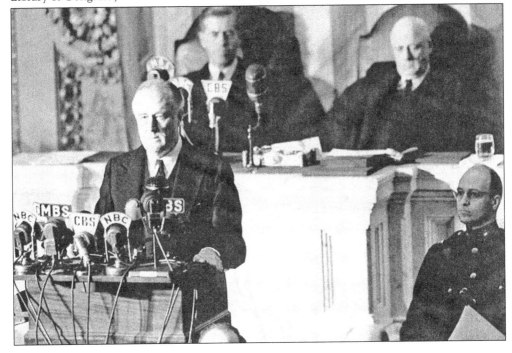

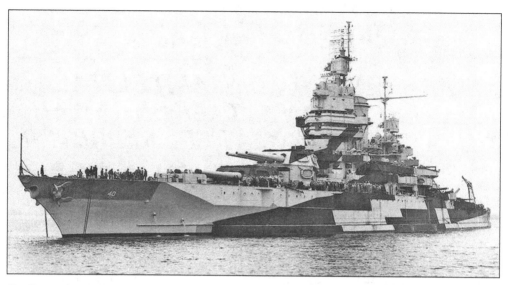

On December 7, 1941, *New Mexico* had dropped anchor in Casco Bay, Maine, awaiting her next assignment as part of the neutrality patrols along the East Coast. When the news of Pearl Harbor arrived, she was immediately ordered to proceed to Puget Sound Naval Shipyard, where she was to be fitted out to engage in the Pacific War. Early on the morning of December 10, *New Mexico* collided with the freighter *Oregon*. Both ships were running with their lights off due to the threat of German submarines. Despite warning signals from escorting destroyers and *New Mexico* turning on her lights, *Oregon* failed to turn in time, and the two ships collided. *Oregon's* captain thought that he could steam back to port, but the weather worsened, and *Oregon* sank, losing 17 crewmen. *New Mexico*, shown above wearing her wartime camouflage paint scheme, proceeded to Norfolk (below) for minor collision repairs. (Both, USN.)

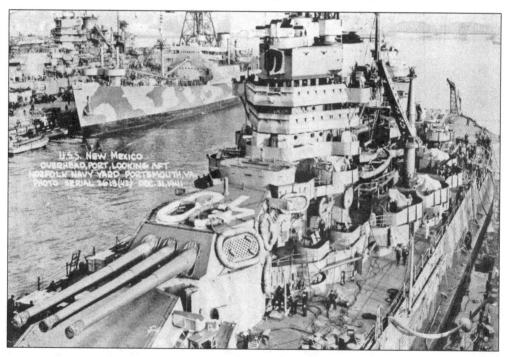

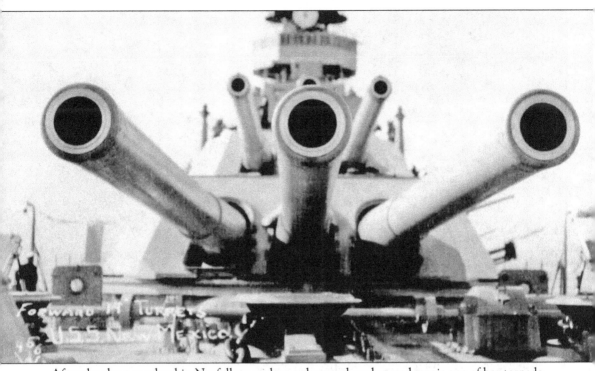

After the short overhaul in Norfolk to replace a damaged anchor and repair one of her torpedo blisters, *New Mexico* headed south, passing through the Panama Canal and sailing up the West Coast. When *New Mexico* arrived in California in 1942, she was first named the flagship of Battleship Division Two under Rear Adm. Theodore Wilkinson and then named the flagship of all Pacific battleships. (USN.)

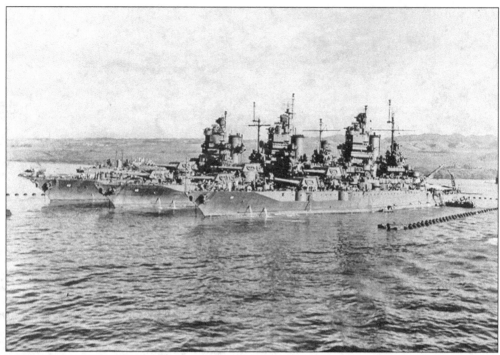

Although it had been almost a year since the attack, Pearl Harbor still showed some of the effects of the damage when *New Mexico* and her sister ships arrived in August 1942. The image above shows *New Mexico*, between *Idaho* and *Mississippi*, at anchor in Pearl Harbor in 1942. Oil still streams up from the sunken *Arizona*, *Oklahoma* is being righted in preparation for being towed back to the mainland, and repairs and salvage and recovery operations both on land and in the harbor are still underway. (Both, USN.)

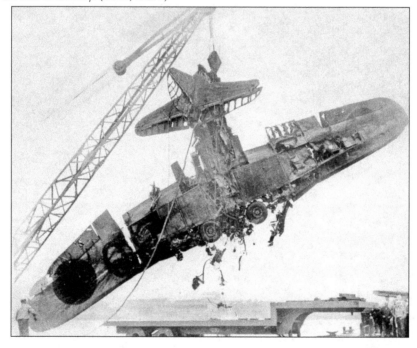

Seven

THANKS!
YOU SAVED THE DAY!
1942–1944

It had been clear to some before World War II, but it was becoming clear to both the Japanese and Allied naval planners during the war, that the historical role for battleships—sinking other battleships—was no longer relevant. After Pearl Harbor in December 1941 and the Battle of Midway in June 1942, it was obvious that carrier-based aircraft were the future of naval warfare.

On the other hand, military leaders like Adm. Chester Nimitz and Gen. Douglas MacArthur were not ready to give up on the battlewagons. Although they might not be as useful in ship-to-ship fighting, they still packed a considerable amount of firepower, and they were highly mobile. This was a perfect combination for the overall strategy of defeating the Japanese in the Pacific.

MacArthur and Nimitz instituted parts of War Plan Orange, a prewar strategy to isolate Japan through an island campaign and selective blockades. They devised a leapfrogging strategy that moved up the island chains in the western Pacific, approaching ever closer to the Japanese home islands. Islands like the Gilberts, the Carolines, the Marianas, the Marshalls, the Philippines, and eventually Okinawa were captured by landing forces that came ashore after the defenses had been softened up by the big guns of battleships like *New Mexico*.

Participating in almost every campaign in the Pacific, *New Mexico* traveled 183,000 nautical miles and spent 544 days (or 40 percent of the war) in combat zones. Her guns fired over 69,000 rounds of ammunition, and her crew suffered 86 deaths, 216 injuries, and five missing men.

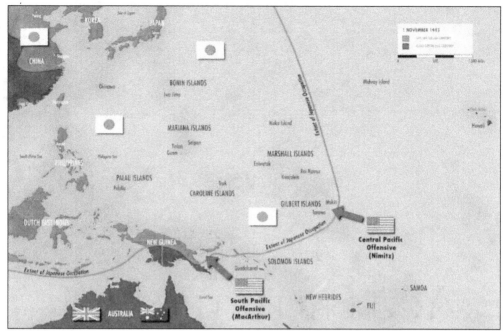

Starting from locations that were under Allied control, such as Pearl Harbor and islands in Melanesia, the Allies moved northeast in a two-pronged attack. One prong moved into the Solomon Islands, with major battles at Guadalcanal, Bougainville, and the Coral Sea. The other moved into the Gilbert Islands, then swung north to the Marshalls, Marianas, and Carolines. Both prongs met at the first prime target—the Philippines. (National World War II Museum.)

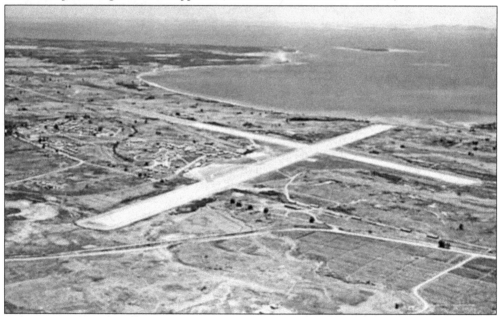

After her overhaul at Puget Sound, *New Mexico* sailed to the South Pacific to escort convoys of troops and supplies into Fiji. Fiji was an ideal location for a training base and airstrip (shown here). From December 18, 1942, through January 1, 1943, *New Mexico* supported final mopping-up operations in the Solomon Islands. (USN.)

In order to protect their northern flank and to threaten the West Coast of North America, the Japanese occupied the Aleutian Islands of Attu and Kiska in June 1942 (above). Because of this threat to their own northern flank, it was necessary for the Allies to drive the Japanese off these islands before the leapfrogging campaign could begin. From the tropical south, *New Mexico* deployed to the arctic north to support the Aleutian Island campaign. Because of the remoteness of the islands, the rugged terrain, and the terrible weather, it took US and Canadian forces over a year to launch a recovery of the islands. (Above, National Park Service; below, USN.)

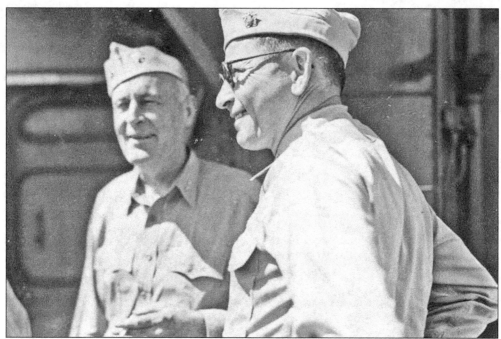

In July 1943, as the flagship of Battleship Division Three under the command of Rear Adm. Robert M. Griffin (above, left, with Capt. Ellis M. Zacharias, commanding officer, USS *New Mexico*), *New Mexico*, along with several other ships, deployed to the Aleutians to support the US recapture of these islands by bombarding the Japanese forces on Kiska. A sustained bombardment lasted from late July to mid-August. During this bombardment, *New Mexico* set a new record by firing 294 fourteen-inch projectiles in less than 23 minutes. When US and Canadian forces finally landed on the island on August 15, they discovered that the Japanese had covertly withdrawn with all of their forces on July 29. (Both, USN.)

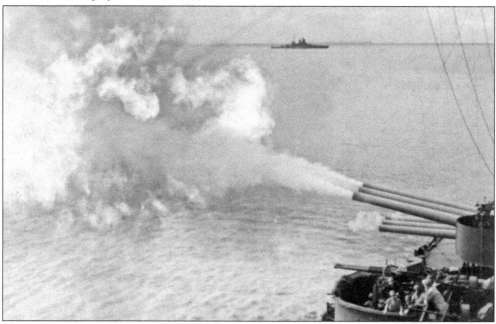

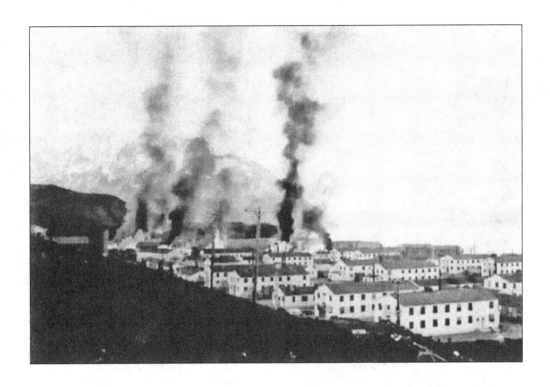

Dutch Harbor on Unalaska, one of the larger islands in the Aleutian chain, was established as a US Army and Navy base. During their campaign against the Aleutian Islands, the Japanese launched a carrier air strike against the US military installation at Dutch Harbor (above), killing 78 men and damaging 14 aircraft and some barracks facilities. The image below shows *New Mexico* at anchor off Unalaska on one of the rare clear days in the North Pacific. Note that the starboard anchor is dropped, and a boarding ladder has been lowered along the port side to accommodate the approaching small craft. (Both, USN.)

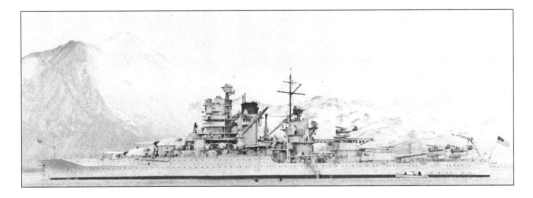

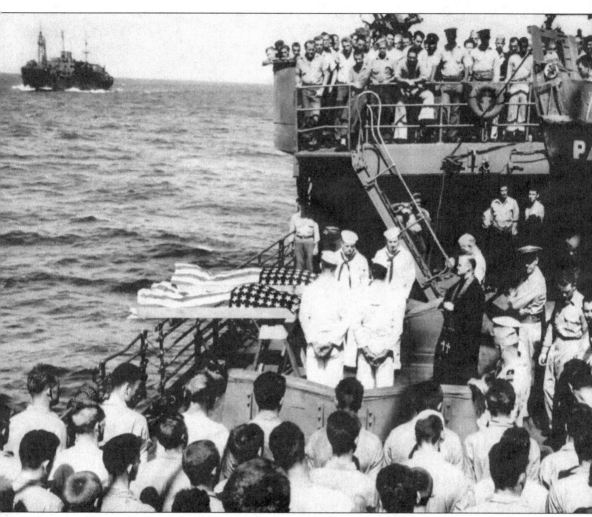

At the conclusion of the Aleutian campaign, *New Mexico* was ordered back to Pearl Harbor. From there, she was deployed to the Gilbert Islands to support the November 1943 assault on Butaritari (known as Makin during World War II), the site of a Japanese seaplane base. During shore bombardment, the escort carrier USS *Liscome Bay* (CVE-56), cruising about 500 yards off the starboard quarter of *New Mexico*, was hit by a torpedo fired by the Japanese submarine *I-175*. Men on the deck of *New Mexico* reported being showered with shards of steel, pieces of decking, and even body parts. The carrier sank, taking with her almost 650 men. *New Mexico* took evasive maneuvers to avoid additional torpedoes fired by *I-175*. Here, crewmen of *Liscome Bay* are buried at sea from the deck of USS *Leonard Wood* (APA-12). (USN.)

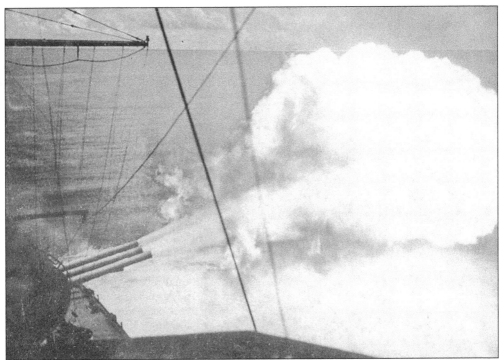

The island of Guam in the Marianas had always been a critical target in the northern prong of the leapfrogging assault on Japan. Between June and July 1944, *New Mexico* supported the recapture of Guam with shore bombardment (above) and direct invasion support. One night during the Marine landing, the *New Mexico* provided near-daylight conditions for the troops by firing 422 star shells to keep the battlefield illuminated for the Marines. Maj. Gen. Roy S. Geiger, commanding the landing forces, wrote a note to Captain Zacharias of *New Mexico* that read "Thanks! You saved the day!" (Both, USN.)

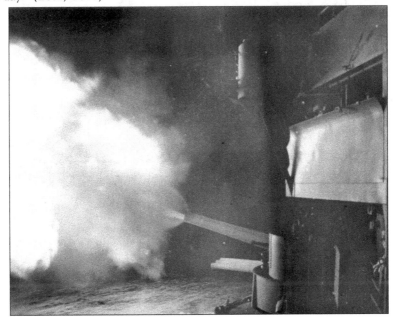

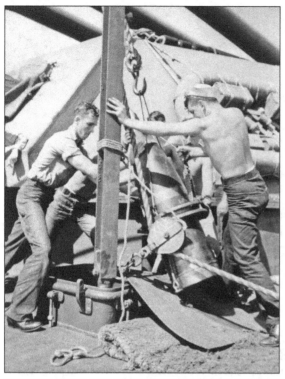

During the Marshall Island campaign, *New Mexico* provided shore bombardment support for amphibious operations at Taroa in the Maloelap Atoll, Wotje in the Wotje Atoll, Kavieng on New Ireland, and Ebeye and Kwajalein in the Kwajalein Atoll. The 14-inch shells from *New Mexico* (left) caused incredible damage to even the most heavily reinforced concrete bunkers on these islands. Below, Comdr. C. Edward Harrison, *New Mexico's* gunnery officer, inspects the damage to a Japanese emplacement on the island of Kwajalein following the intensive shore bombardment by the battleship. (Both, USN.)

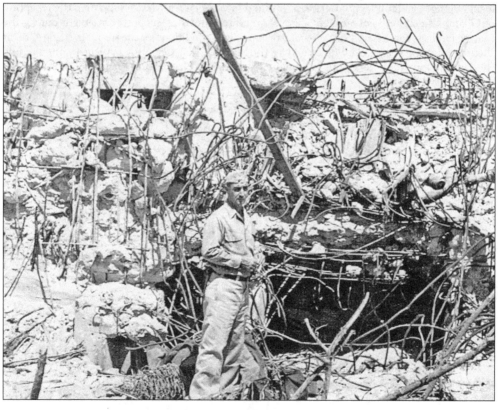

Whether training for battle, participating in fleet demonstrations, or actually firing in combat, *New Mexico* fired thousands of rounds from her 5-inch and 14-inch batteries. For example, during the course of the bombardments in the Marshall and Mariana Islands, *New Mexico* expended nearly 9,000 rounds of ammunition. Pictured is a rearming operation in July 1944. (USN.)

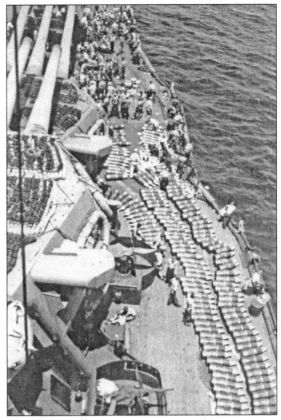

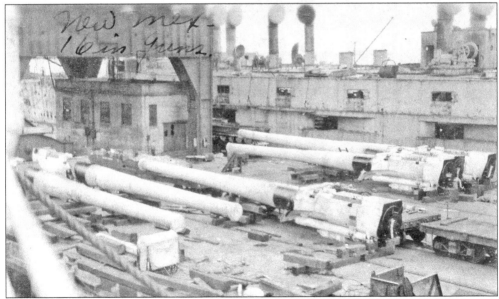

Each of the guns in the main batteries on *New Mexico* weighed almost 180,000 pounds, cost approximately $95,000 ($1.2 million in today's dollars), and had a barrel that was just over 58 feet long. At the time, it was estimated that each time a gun was fired, it cost $755 ($10,000 in today's dollars). Here, new gun barrels are ready for installation. (USN.)

New Mexico suffered its first casualty of the war on January 1, 1944, during the Marshall Island campaign. The victim was Lt. Forney O. Fuqua, the pilot of one of New Mexico's scout planes. While spotting rounds over Kwajalein, Fuqua's OS2U-2 Kingfisher was hit by enemy gunfire, and Fuqua was critically injured. Before he lost consciousness, Fuqua ordered his radioman, PO3 Harrison Miller, to parachute to safety. However, Miller stayed with the plane and attempted to land the Kingfisher in the water. Unfortunately, the plane capsized. Miller unsuccessfully attempted to free Fuqua from the sinking plane. Although rescued, Miller was severely burned from exposure to the aviation fuel in the water. Miller was awarded the Distinguished Flying Cross by Captain Zacharias for his bravery (left). Note that GM2 James Kennedy, author of the foreword to this book, is the first sailor on the right in the first row. (Both, USN.)

Eight

I SHALL RETURN
1944–1945

Control of the Philippine Islands was critical to the Japanese war effort. The islands provided a land base for the aircraft that protected ships bringing petroleum and other critical supplies from South Asia to the Japanese homeland. Gen. Douglas MacArthur also recognized the strategic importance of the islands for the Allies. When he and the Allied forces were driven off the islands in March 1942, he famously vowed, "I came through, and I shall return."

In June 1942, having attained naval superiority in the eastern Pacific following the Battle of Midway, General MacArthur and Adm. Chester Nimitz seized the initiative. They launched their two-pronged leapfrogging campaign, designed to capture the Pacific islands one by one, advancing toward Japan and bypassing or isolating any local resistance. MacArthur pushed northwest along the New Guinea coast and into the Bismarck Archipelago with the eventual aim of liberating the Philippines; Nimitz crossed the central Pacific, hopping through the Gilbert, Marshall, Caroline, and Marianas Islands. The execution of the plan would place Japan within the range of US bombers and eventually position the Allies to launch an invasion of the Japanese homeland to end the war.

New Mexico had provided critical shore bombardment support throughout Nimitz's northern prong of the campaign. Her 14-inch guns had helped to subdue Japanese resistance on Makin, Guam, and Kwajalein, to name just a few. Now it was time for the final push north.

By mid-1944, MacArthur was ready to move against the Philippines themselves, and on October 20, he fulfilled his promise when he waded ashore on Leyte. Throughout the Philippine campaign, *New Mexico* provided critical gunfire and escort support.

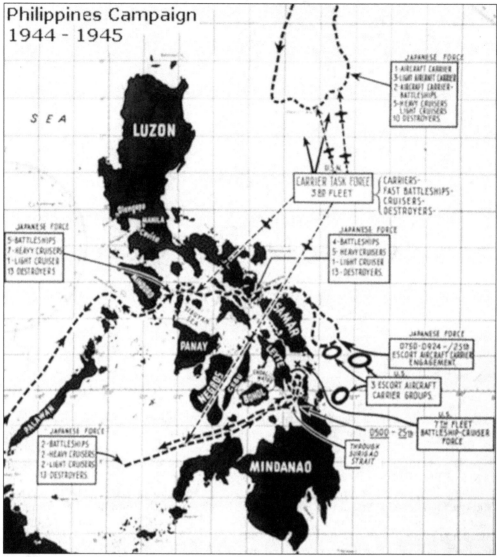

Philippines Campaign 1944 - 1945

The Philippine Islands represented a key link in the island-hopping push toward Japan. The Allied assault on the Philippines began with attacks on the central island of Leyte on October 20, 1944. After Leyte was secured, Allied forces moved north, first to Mindoro on December 13, 1944, and then to Luzon, the largest of the islands, on December 15, 1944. Operations on Luzon were completed at Corregidor on February 27, 1945. The last of the islands to be captured was the southern island of Mindanao, invaded on April 17, 1945. Stubborn resistance continued there until the Japanese surrender on August 15, 1945. (USN.)

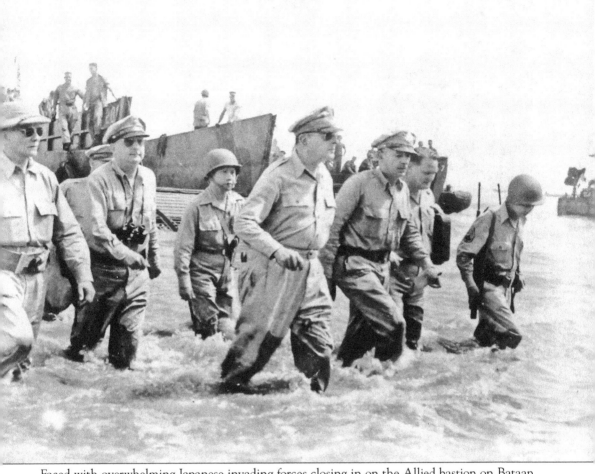

Faced with overwhelming Japanese invading forces closing in on the Allied bastion on Bataan in 1942, President Roosevelt sent General MacArthur the following order: "The President directs that you make arrangements to leave and proceed to Mindanao. You are directed to make this change as quickly as possible. . . . From Mindanao you will proceed to Australia where you will assume command of all United States troops. . . . Instructions will be given from here at your request for the movement of submarine or plane or both to enable you to carry out the foregoing instructions." MacArthur and his family left the island of Corregidor in a patrol torpedo boat on the night of March 12, 1942. His return, shown above, was far more triumphal than his departure, and very much in keeping with his character. He and his staff waded ashore on Leyte on October 20, 1944, fulfilling his famous promise to return. (Library of Congress.)

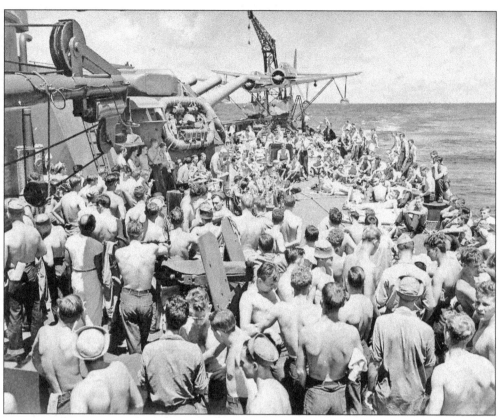

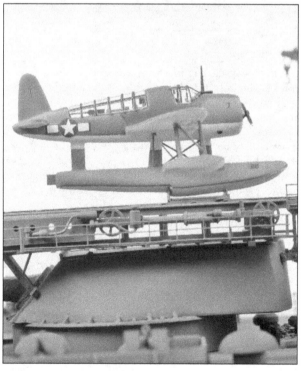

The image above shows *New Mexico's* crew during the Philippine campaign. A group of musicians in the center is conducting an informal concert on the forecastle. *New Mexico* supported the Philippine campaign both with shore bombardment and by performing escort duties for landing support and carrier forces in the Surigao Strait, the Mindanao Sea, and the Sulu Sea. During one of the shore bombardment assignments, *New Mexico* targeted two bridges that were completely obscured behind a set of hills. A Kingfisher spotter plane (at left on its launching catapult) flew over the hills and sent back coordinates. After a few spotting rounds, the gunners in the 14-inch turrets fired a round that hit the first bridge, destroying it. A second shot severely damaged the second bridge. (Both, USN.)

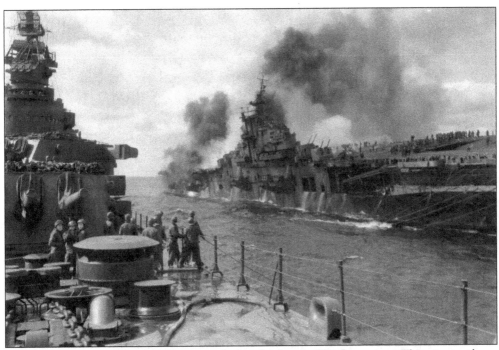

New Mexico was not the only ship named after the Land of Enchantment. This picture shows the cruiser USS *Santa Fe* (CL-60), famously risking her own safety by coming to the aid of the burning USS *Franklin* (CV-13) on March 19, 1945. The carrier had been hit by two Japanese bombs. *Franklin* survived earlier kamikaze attacks, but this attack put her out of action for the rest of the war. (USN.)

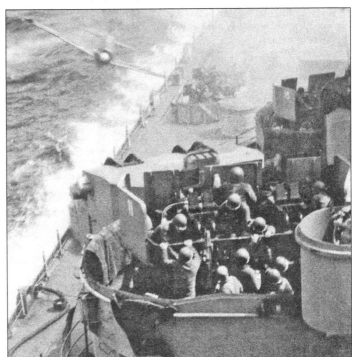

Kamikaze attacks sank 34 US Navy ships and damaged 368 others. This image shows a kamikaze attack on the USS *Missouri*. In kamikaze attacks, 4,900 American sailors were killed and 4,800 were wounded. The Japanese lost 4,912 kamikaze pilots. (USN.)

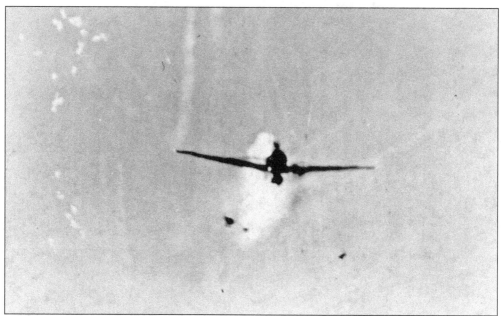

About noon on January 6, 1945, during shore bombardment operations in the Lingayen Gulf off the island of Luzon, a kamikaze carrying a 500-pound bomb (shown above) hit *New Mexico's* port navigation bridge, knocking out two antiaircraft guns. The attack killed 30 men, including the captain and several other officers, and wounded 87. Comdr. John T. Warren, the executive officer of *New Mexico*, assumed command, and the ship continued to shell the Japanese shore positions to soften them up prior to the Marine landings on Leyte. *New Mexico* continued to support the Lingayen Gulf operation until January 22, when she withdrew to San Pedro Bay off Leyte for temporary repairs prior to returning to Pearl Harbor for a more complete refit. During the shelling of Luzon, *New Mexico* expended 25,795 rounds totaling 1,391,975 pounds. (Above, USN; below, Mark Stille.)

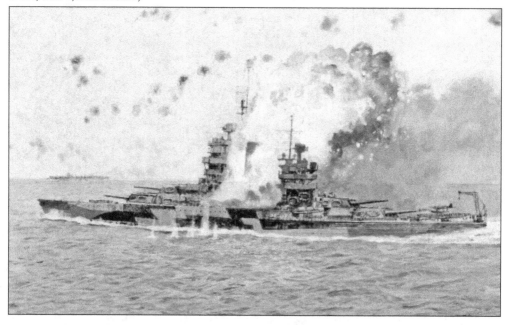

The commanding officer of *New Mexico*, Capt. Richard Fleming (right), was mortally injured in the January 6 attack. When a crewman rushed to his aid, the captain asked, "Is the ship alright?" Assured that it was, he died. Included among the dead were *Time* magazine's war correspondent William Chickering (below) and British lieutenant general Herbert Lumsden, who was overseeing other Allied forces. (Right, Richard Melzer; below, Greg Trapp.)

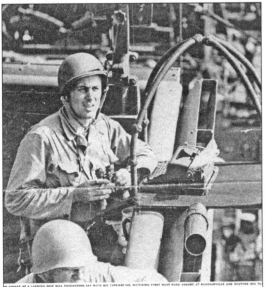

ON BRIDGE OF A LANDING SHIP BILL CHICKERING SAT WITH HIS TYPEWRITER, WATCHING FIRST WAVE PUSH ASHORE AT BOUGAINVILLE AND WAITING HIS TU

BILL CHICKERING DIES IN ACTIO

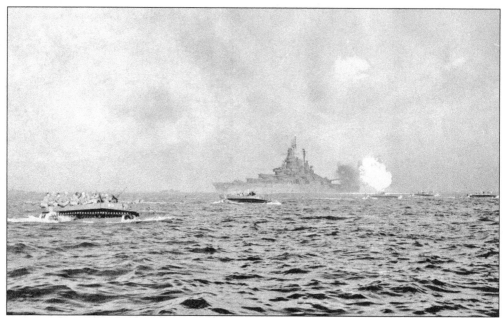

As the Allies moved closer and closer to their home islands, Japanese resistance stiffened. Okinawa was only 400 miles from Japan and was a perfect location to prepare for the invasion of the Japanese homeland. The island was finally conquered in an 82-day battle that cost 12,500 American and over 101,000 Japanese lives. *New Mexico* spent 64 days performing shore bombardment and expended 21,876 rounds of ammunition during the Okinawa operation. (USN.)

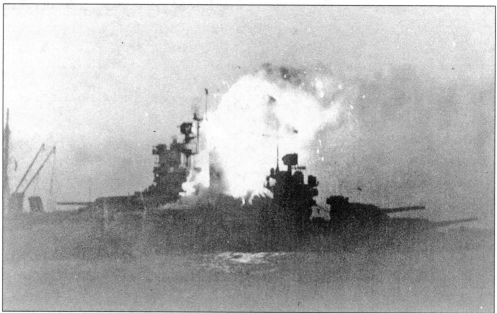

While operating off Okinawa just after sunset on May 12, 1945, *New Mexico* suffered a second kamikaze attack. The kamikaze struck the ship just aft of the funnel, where its 500-pound bomb exploded. The attack killed 54 men and wounded 119. The ship experienced significant damage and sailed to Leyte for repairs and to prepare for Operation Downfall, the anticipated invasion of the Japanese home islands. (USN.)

Nine

JAPAN'S UNCONDITIONAL SURRENDER 1945

By the spring and summer of 1945, it was clear that Japan could not win the war. The Allies planned Operation Downfall, an invasion of the Japanese home islands under the direction of General MacArthur. Expecting stiff resistance, American casualties were anticipated to be as high as four million, with between 400,000 and 800,000 fatalities. During the first phase of the invasion, Operation Olympic, it was estimated that death rates could be as high as 1,000 men per day. Japanese casualties were anticipated to be as high as five to ten million, including millions of women and children. *New Mexico* was to provide shore bombardment and escort support for the invasion.

On August 6, 1945, invasion predictions became moot when the United States dropped an atomic bomb on the city of Hiroshima, Japan. Three days later, a second atomic weapon struck the city of Nagasaki. The devastation caused by these powerful new weapons stunned the emperor of Japan, convincing him to override the wishes of his hardened military advisors and accept the unconditional surrender demanded by the Allies.

Japan officially surrendered on August 15, 1945. The instruments of surrender were signed on the deck of USS *Missouri* in Tokyo harbor on September 2, 1945. Gen. Douglas MacArthur initiated the surrender ceremonies by saying:

> It is my earnest hope—indeed the hope of all mankind—that from this solemn occasion a better world shall emerge out of the blood and carnage of the past, a world founded upon faith and understanding, a world dedicated to the dignity of man and the fulfillment of his most cherished wish for freedom, tolerance, and justice.

New Mexico was anchored in Tokyo Bay so near *Missouri* that her crew was able to witness the surrender ceremonies.

The crew of *New Mexico* fully expected to be involved in shore bombardment to support the invasion of the Japanese home islands, known as Operation Downfall. However, at 8:15 a.m. local time on August 6, 1945, Maj. Thomas Ferebee, bombardier of the B-29 *Enola Gay* (shown here before her historic mission), dropped the 9,700-pound Little Boy atomic bomb on the city of Hiroshima, Japan. Three days later, on August 9, a second atomic weapon, Fat Man, was dropped on the city of Nagasaki. The combined impact of these bombs effectively ended World War II, halting invasion planning and forever changing the nature of warfare. (Department of Energy.)

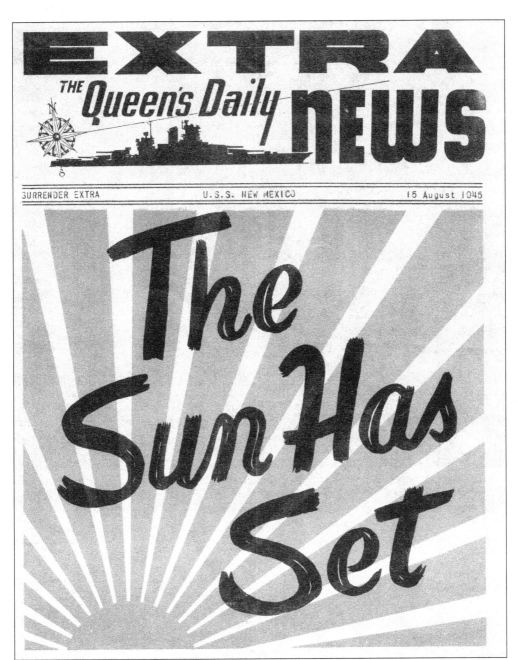

EXTRA

THE Queen's Daily NEWS

SURRENDER EXTRA · U.S.S. NEW MEXICO · 15 August 1945

The Sun Has Set

Newspapers and radio broadcasts across the globe, read and heard in countless languages by hundreds of millions of people, had the same message on August 15, 1945. World War II, the deadliest war in the history of the world, had finally come to an end. A recorded message from Emperor Showa, the 124th emperor of Japan, better known to the rest of the world by his personal name, Hirohito, announced that the Empire of Japan had agreed to the unconditional surrender terms of the Allied forces. *New Mexico's* newspaper, *The Queen's Daily News*, was no exception, proclaiming "The Sun Has Set." The crew received the news that they would be sailing with the rest of the Third Fleet for the formal signing of the surrender documents in Tokyo Bay. (Richard Melzer.)

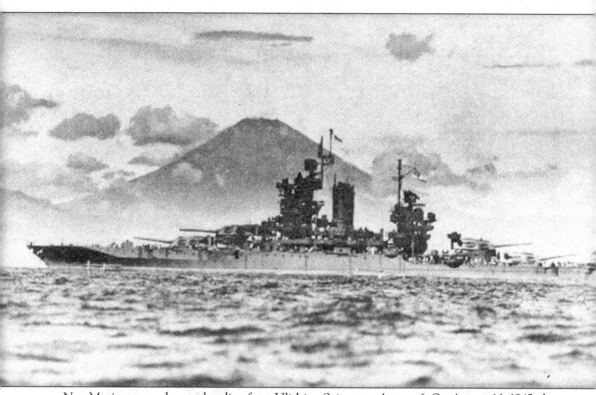

New Mexico was underway, heading from Ulithi to Saipan on August 6. On August 16, 1945, she arrived at Okinawa. She left Okinawa with the Third Fleet on August 23 and arrived in Tokyo Bay on August 29. Pictured is *New Mexico* at anchor with Japan's iconic Mount Fuji in the background. The mighty battleship had seen combat from the tropics to the arctic. In the nearly five years she had spent in the Pacific, more than 300 of her crewmen had been killed or wounded, and she had expended over 12 million pounds of ammunition. Now the endless days of battle stations and kamikaze attacks were over. She had witnessed the end of World War I when she escorted President Wilson to France. Now she would witness the end of World War II. (USN.)

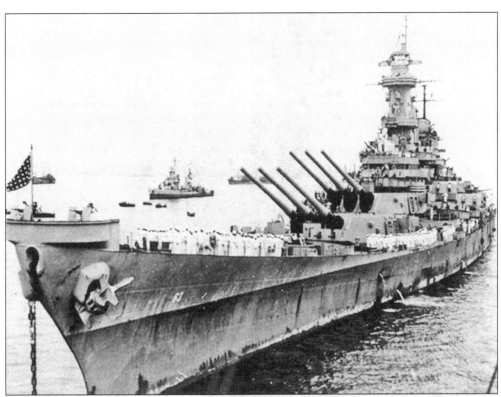

USS *Missouri* (BB-63), flagship of Adm. William F. "Bull" Halsey, commander of the US Third Fleet, dropped anchor in Tokyo Bay on August 29, 1945 (above). Gen. Douglas MacArthur and Fleet Admiral Chester Nimitz came aboard early on the morning of September 2, joined by Allied representatives from China, Britain, the Soviet Union, Australia, the Netherlands, France, Canada, and New Zealand. At 9:02 a.m., General MacArthur initiated the surrender formalities (right). Significantly, the flag framed on the superstructure of *Missouri* in the image at right is the same flag flown by Commodore Matthew Perry when he entered Tokyo Harbor in 1853, first opening Japan to the outside world. (Both, USN.)

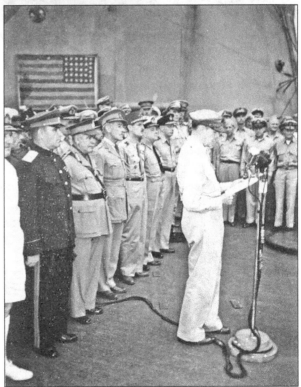

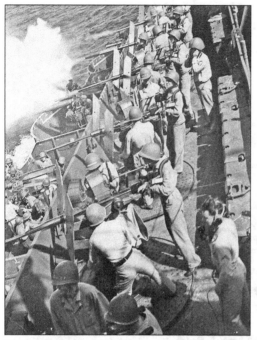

Even though Hitler was dead, Germany was in shambles, and Imperial Japan had capitulated, the world was still a dangerous place, and the need for vigilance remained. For *New Mexico*, this meant that training remained a daily task. These images show gun crews practicing. The image at left shows the antiaircraft guns being operated by helmeted crewmen. The image below, called "Crossed Barrels," shows the 14-inchers being aimed in response to commands from the spotters with binoculars. That this is training rather than actual fighting is suggested by the sailor on the far right, lounging on the deck with his feet dangling over the edge. *New Mexico* maintained her fighting trim right up until the day she entered Boston Harbor for decommissioning. (Both, USN.)

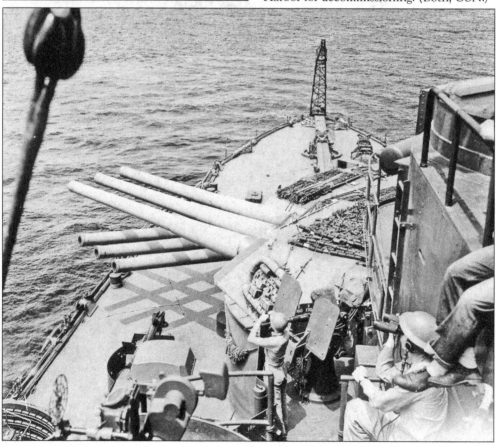

Ten

A LASTING LEGACY
PASSING THE TORCH

Only eight of the US battleships that survived the two world wars are extant today. These proud battlewagons are on display in various ports (USS *Alabama* in Mobile, Alabama; USS *Iowa* in San Pedro, California; USS *Missouri* in Honolulu, Hawaii; USS *Massachusetts* in Fall River, Massachusetts; USS *New Jersey* in Camden, New Jersey; USS *North Carolina* in Wilmington, North Carolina; USS *Texas* in La Porte, Texas; and USS *Wisconsin* in Norfolk, Virginia). Of course, USS *Arizona* still lies below the waves in Pearl Harbor, a permanent gravesite for the 1,102 American sailors who died aboard her on December 7, 1941.

Sadly, *New Mexico* did not escape the scrapper's furnace. However, her legacy lives on. Several artifacts, including two ship's bells, her battle flag, a 56-piece silver service, and her helm, were preserved and are on display at various sites in the state of New Mexico.

In addition, land-locked New Mexico's naval heritage did not die with the scrapping of the battleship. Nearly 80 additional naval vessels have been named for the state and its various cities, counties, rivers, Native American tribes, military heroes, and geographical features.

Most of all, this great ship, the only one to have directly participated in ceremonies ending two world wars, lives on in the ongoing accomplishments of USS *New Mexico* (SSN-779), the Navy's sixth Virginia-class nuclear attack submarine, and in the memories and stories of the families of the nearly 10,000 men who served aboard her. It is to them that this work is dedicated.

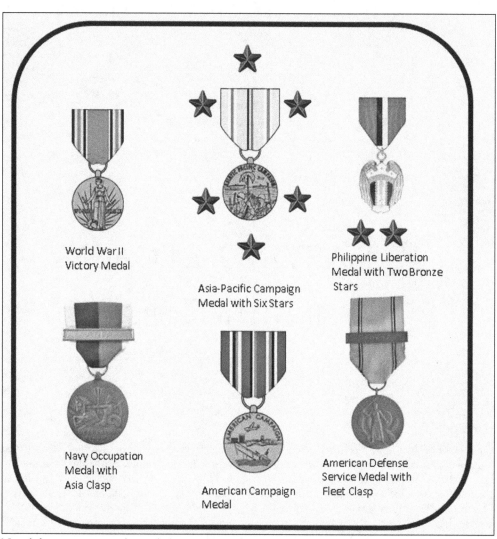

World War II
Victory Medal

Asia-Pacific Campaign
Medal with Six Stars

Philippine Liberation
Medal with Two Bronze
Stars

Navy Occupation
Medal with
Asia Clasp

American Campaign
Medal

American Defense
Service Medal with
Fleet Clasp

Naval ships were granted awards for exceptional performance during wartime. Crewmen who had served during the period of time that the awards covered were entitled to wear the medals or their corresponding ribbons on their dress uniforms. The awards shown here were earned by *New Mexico* for her service during World War II. Perhaps the most significant is the Asia-Pacific Campaign medal with its six battle stars. The most decorated US warship in World War II was the aircraft carrier USS *Enterprise* (CVA-6), which received 20 battle stars. *New Mexico* received six battle stars for her participation in the campaigns in the Aleutian Islands (Attu, Kiska, and Unalaska), the Gilbert Islands (Makin/Butaritari), the Marshall Islands (Kwajalein), the Marianas (Guam, Tinian, and Saipan), the Philippines (Lingayen Gulf), and the Ryukyus (Okinawa). (USN.)

From November 15, 1946, to July 19, 1947, Comdr. Arnold H. Newcomb oversaw the preparation of *New Mexico* for decommissioning. After nearly 30 years of service to the nation, the Queen was decommissioned in Boston on July 19, 1946, and struck from the register of naval vessels on February 25, 1947. The two postal covers shown here bracket the decommissioning dates while also commemorating the centennial of the capture of New Mexico from Mexico by Gen. Stephen Watts Kearny in 1846, at the start of the Mexican War. Note that the image above shows the battleship in its initial configuration with its cage masts. (Both, Richard Melzer.)

Name	Dates
Ashley Herman Robertson	May 1918 - September 1918
Lucius Allyn Bostwick	September 1918 - May 1919
Arthur Lee Willard	May 1919 - May 1921
George Washington Williams	May 1921 - June 1922
Yates Stirling, Jr.	June 1922 - June 1924
Frank Hardeman Brumby	June 1924 - October 1926
William Daniel Leahy	October 1926 - October 1927
Edgar Brown Larimer	October 1927 - May 1929
Adolphus Eugene Watson	May 1929 - June 1931
Herbert Claiborne Cocke	June 1931 - June 1933
David Allen Weaver	June 1933 - November 1934
Clarence Carroll Soule	November 1934 - June 1936
Frank Jack Fletcher	June 1936 - December 1937
Walter Frederick Jacobs	December 1937 - June 1939
Cortland C. Bauchman	June 1939 - January 1941
Walter Elliot Brown	January 1941 - September 1942
Oliver Lee Downes	September 1942 - September 1943
Ellis Mark Zacharias, Sr.	September 1943 - September 1944
Robert Walton Fleming	September 1944 - January 1945
John Thompson Warren	January 1945 - March 1945
John Meade Haines	March 1945 - November 1945
Arnold Houghton Newcomb	November 1945 - July 1946

In the early to mid-20th century, command of a battleship was a stepping stone for promotion to admiral, and *New Mexico* was an especially prestigious command. Seven of the 21 men who skippered the ship during her active career were promoted to admiral, including William Leahy, who was promoted to fleet admiral (the Navy's highest rank), and Ashley Robertson, her first commanding officer, who was promoted to vice admiral after taking the ship through commissioning, sea trials, and her initial shakedown in 1918. She was also captained by Frank J. Fletcher, who would play a prominent role as a rear admiral during the Battle of the Coral Sea and the Battle of Midway. One of her commanding officers, Robert Walton Fleming, was killed in the line of duty. Tours of duty for commanding officers were typically between one and two years. However, several skippers served for less than a year, with the longest assignment being two years and five months—Frank Brumby, from 1924 to 1926—and the shortest being three months—Comdr. John Warren assumed command after Captain Fleming was killed in the kamikaze attack on January 6, 1945. (USN.)

A longstanding naval ritual for ships in port is retiring the colors at sunset. The in-port duty officer and the topside crewmen stand at attention while the flag is lowered. At most military installations, all traffic stops while the national anthem is played over the public-address system. After nearly three decades of service, the colors were hauled down under the command of Comdr. Arnold Newcomb on *New Mexico* for the last time in Boston Harbor on July 19, 1946. The ship that had sailed from the North Atlantic to the South Pacific and witnessed the end to the two most devastating wars in human history was finally sailing into history herself. (Both, USN.)

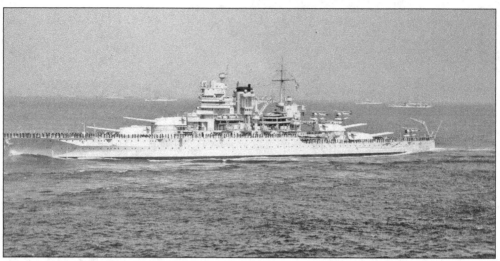

New Mexico, shown above with her crew lining the rails as she passes in review in New York Harbor, was home to nearly 10,000 men during her 29 years and three months of commissioned service. Nearly 100 of these men died in combat or from accidents. The vast majority of sailors were either transferred to other ships or were discharged from the Navy. The honorable discharge certificate below was awarded to Naval Reserve seaman second class John Douglas Carrick, who spent his entire two-and-one-half-year active-duty career aboard the Queen. He was discharged in Boston after the ship arrived there in preparation for decommissioning. (Above, USN; below, Richard Melzer.)

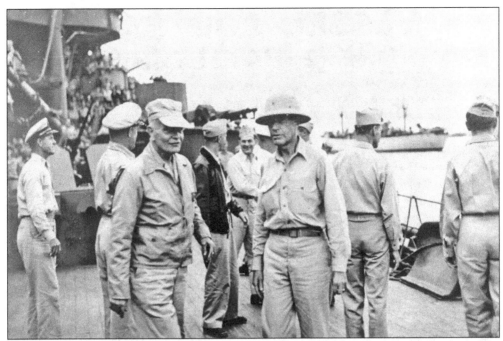

New Mexico welcomed men from the highest ranks of the Navy to the working sailor. Each was equally important, and the successful completion of the various assigned missions of the battleship depended as much on the leadership of the senior officers as it did on the work performed by the most junior crewmen. Above are Admirals William "Bull" Halsey, commanding officer of the Third fleet (left), and Raymond Spruance, commanding officer of the Fifth Fleet (right), on board the Queen during the Pacific campaigns. The image below shows the Aviation Division mustered under the wing of the Kingfisher scout plane. (Both, USN.)

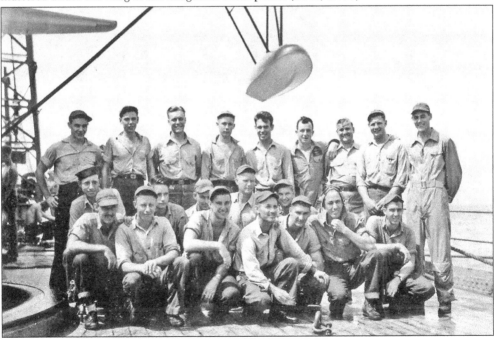

VESSEL FOR SALE
ONE (1) BATTLESHIP

LOCATION: Commonwealth Pier 1, East Boston, Mass.

Bids Accepted Until 30 September 1947
For Complete Details Ask for Catalog B-10-48AV

Estimated Weight...30,600 Tons
Length (Overall)... 624 Feet
Extreme Beam... 106 Feet
Mean Draft (Full Load).. 34 Feet
Equipment: Four (4) impulse reaction cross-compound single flow
type turbine units 10000 SHP each unit.

U. S. NAVY VESSEL DISPOSAL OFFICE
New York Naval Shipyard
Bldg. #3, 11th Floor, Brooklyn 1, N. Y.
CUmberland 6-4500, Ext. 2355

In keeping with standard policy, the Navy advertised for contractors to purchase the decommissioned *New Mexico* for its scrap value (above). In 1947, scrap iron and steel sold for $38 per metric ton (the price rose to $40 per metric ton in 1948). The Lipsett Division of Luria Brothers from Newark, New Jersey, won the contract with a bid of $381,600, standing to gross between $677,000 and $820,000 (note the Lipsett name amidships on the port side below). The company made the decision to dismantle the ship in its facilities in Newark, New Jersey. The decommissioned battleship left Boston Harbor under tow on November 11, 1947. (Above, Richard Melzer; below, USN.)

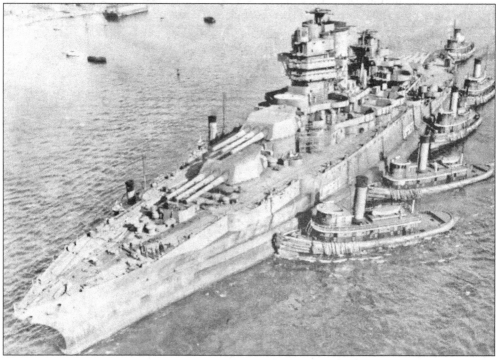

Where New Mexico Drifted at Sea

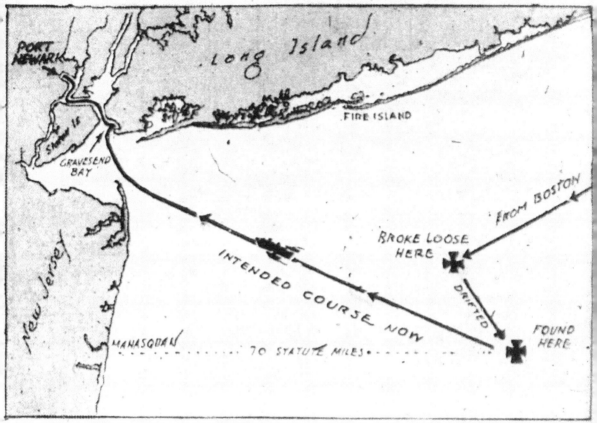

Newark News map shows spot where battleship was cast loose from tugs during night and drifted southeast before she was found by search plane 70 miles off Manasquan.

Towing a nearly 31,000-ton hulk can be treacherous under the best of conditions, but weather off the south coast of Long Island can be unpredictable in the late fall and early winter. Days can be spectacular with sunshine, light winds, and calm seas. Alternatively, storms can come up suddenly with high winds and waves. In mid-November 1947, the weather did not cooperate, and during the tow from Boston to Newark, the towlines broke in heavy seas. *New Mexico* drifted and wallowed in a southeasterly direction in high seas with running lights on and three (no doubt very concerned) crewmen aboard. The Coast Guard immediately started a search from her last known position and found her about 24 hours later. The tugs were called out to reattach the towlines. This map from the *Newark Evening News* of November 13, 1947, shows where *New Mexico* drifted after breaking her tow. (Richard Melzer.)

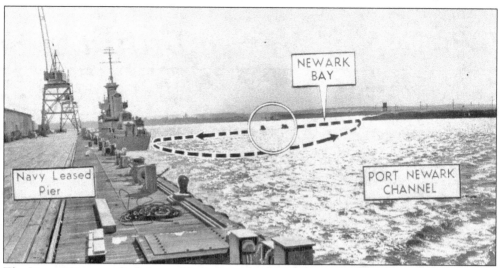

The Lipsett Company had chosen Newark for dismantling the battleship because its proximity to rail lines would make it easy to haul away the scrap steel. However, Newark had embarked on a $70-million waterfront beautification program and felt that battleships being scrapped in the center of the project would not enhance the desired image. To that end, the city dispatched two of its fireboats, *Michael P. Duffy* and *William T. Brennan*, to prevent *New Mexico* from entering the harbor. The image above shows the fireboats' patrol zone, and the image below shows what might have happened if the Newark fireboats attempted to stop the *New Mexico*. This is clearly an early version of photoshopping. The city of Santa Fe, New Mexico, registered a protest against Newark's slur of the state's namesake. (Both, Richard Melzer.)

Here is one of Newark's doughty fireboats as it might assail the New Mexico in the background.

The process of turning *New Mexico* into scrap began on November 24, 1947, after the so-called "Battle of Newark Bay" had been settled via threats from the Coast Guard and negotiations between the mayor of Newark and the secretary of the Navy. Per agreement, the company had six months to complete the scrapping of *New Mexico* (near right below), *Idaho*, and *Wyoming*. One by one, guns that had helped to win World War II were removed, electronics that had helped to navigate the Atlantic and Pacific were salvaged for precious metals, and eventually, the hull that had cut through heavy seas from the tropics to the arctic was cut up and melted down. The Lipsett Company completed the job in July 1948. (Both, USN.)

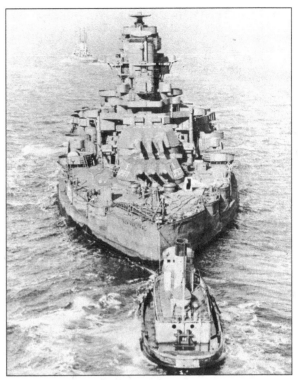

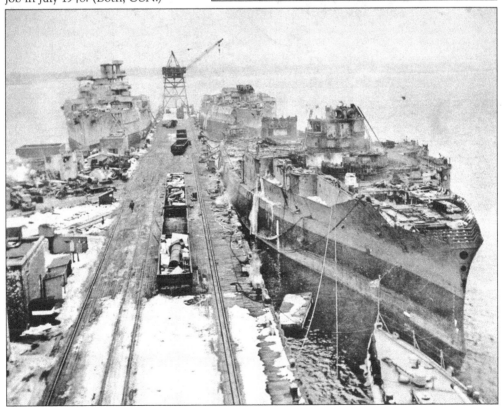

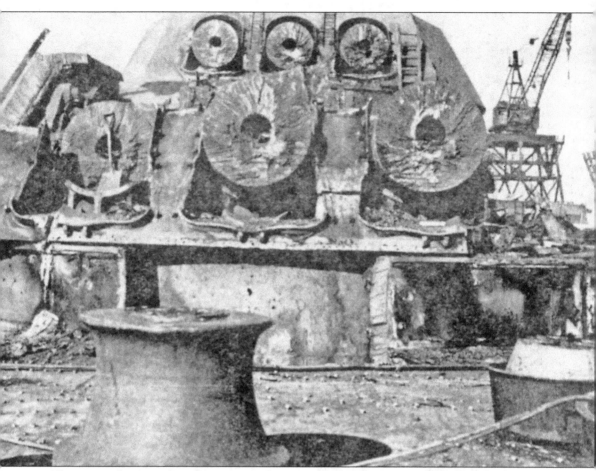

This image illustrates the scrapping process in very graphic form. Once important artifacts such as the ship's bells, the helm, and a few other items of sentimental value had been salvaged, the scrapping crew from Lipsett took over, removing major pieces like the masts, the catapult, and items that were bolted or welded into place, and then working from the top to the bottom of the ship with cutting torches until nothing but memories remained of the Queen. In this image, six of the 90-ton barrels of the 14-inch guns from two of the forward turrets have simply been cut off with a torch. They were then cut into "bite-sized" pieces, fed into a melting furnace, and turned into ingots. Note the shovel leaning against the barrel stub at left—even the cutting slag and small pieces were captured for recycling. (John Wickland.)

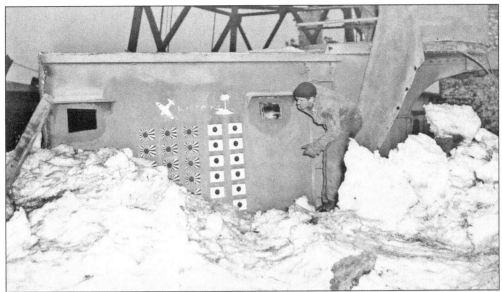

A Newark dock worker inspects the part of the superstructure where the war record of *New Mexico* was proudly updated and displayed like nose art on a fighter aircraft as the Queen fought her way across the Western Pacific. The symbols on the right, below the icon of a palm tree on a Pacific island, are 11 Japanese national flags, each representing a bombardment assignment. The symbols on the left, below the icon of an airplane, are 21 Japanese naval flags, each representing a Japanese plane that *New Mexico* shot down. This portion of the superstructure had been cut off and placed on the dock, allowing workers access to cut it up while others worked on the main deck. This photograph was taken after a major snowstorm hit Newark and the East Coast in 1947. (Richard Melzer.)

Through the efforts of New Mexico governor Thomas Mabry, two of *New Mexico's* 1,100-pound bells were saved from the scrap heap. One of the bells was displayed in a monument on the Plaza in Santa Fe and is now in storage at the Museum of New Mexico. The original display (pictured) was dedicated in 1948 by Governor Mabry and Santa Fe mayor Frank Ortiz. (Richard Melzer.)

The second bell was acquired by the University of New Mexico, with the help of the Alpha Phi Omega fraternity, and was placed in the bell tower at Scholes Hall. In 1964, it was moved to its present location just southeast of Zimmerman library. The plaque on the tower reads, "A memorial to those men and women who served their country in World War II." (John Taylor.)

The ship's wheel, removed from the bridge during dismantlement, is proudly displayed in a conference room at the Naval Reserve Officer Training Corps (NROTC) building on the campus of the University of New Mexico. In addition, the NROTC unit has several other artifacts and photographs from the battleship. (John Taylor.)

This is the battle flag that flew on USS *New Mexico* during her time fighting in the Pacific. The flag was donated to the State of New Mexico in 1946 by Rear Adm. George Lester Weyler in a formal ceremony as a part of the Stephen Watts Kearney Centenary Program, jointly sponsored by the Historical Society of New Mexico and the Archeological Society of New Mexico. (Museum of New Mexico.)

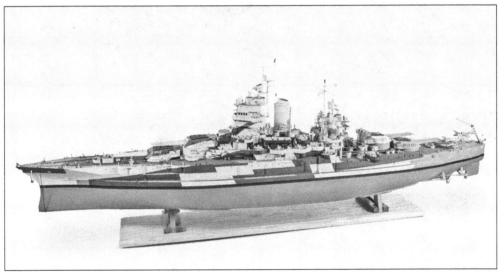

In January 2011, the Museum of New Mexico opened an exhibit entitled A Noble Legacy: The USS *New Mexico*. This exhibit recognized the historic contributions that the battleship made during World War II and acknowledged the importance of the submarine USS *New Mexico* (SSN-779). Several artifacts were displayed, including the Tiffany silver set donated to the battleship in 1918. One of the most impressive artifacts in the exhibit was this seven-and-a-half-foot-long, scratch-built scale model of USS *New Mexico*, completed over a period of 30 years by Cecil Whitson and Keith Liotta. Whitson started the model in the 1960s but was unable to complete it due to ill health. Navy veteran and fellow modeler Liotta stepped in and completed this incredible project. Each part was handcrafted, using detailed drawings and ship specifications. (Museum of New Mexico.)

A 56-piece silver service was donated to the battleship *New Mexico* by the state in 1918. The silver service was designed in New Mexico and produced by Tiffany & Company. Before the ship was decommissioned, the silver service was sent to the Museum of New Mexico. Several items from the set are now on display at the museum. Pictured is a silver cigar humidor crafted to represent Taos Pueblo, presented on a silver tray. (Museum of New Mexico.)

The Tiffany connection to New Mexico actually goes back to the middle of the 19th century, when the company introduced a product that came to be known as the Tiffany Blue Box. The company's gemologist, George F. Kuns, declared that this particular shade of blue, called Tiffany Blue, was based on turquoise from mines around Cerrillos, New Mexico. Shown here are two of the engraved plates from the 56-piece collection formerly on the battleship *New Mexico* that were loaned back to the Navy and are on display in the wardroom of the nuclear submarine USS *New Mexico* (SSN-779). They are periodically exchanged with others in the museum collection. The plates shown here depict the Santa Fe Trail (top) and Taos Pueblo (bottom). (Both, Museum of New Mexico.)

123

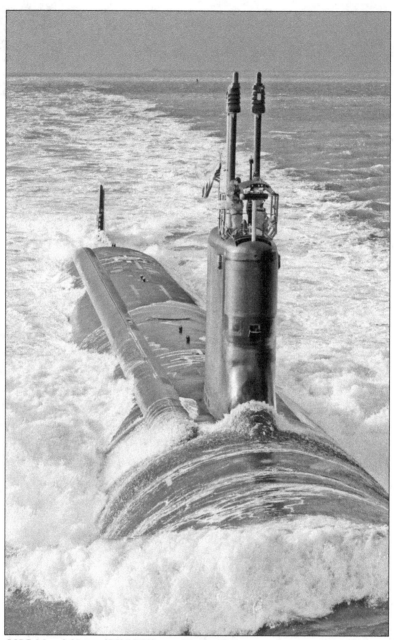

The latest USS *New Mexico* (SSN-779) is a Virginia-class nuclear attack submarine launched from Newport News Shipyard in Newport News, Virginia, on January 18, 2009, and delivered to the Navy on December 29, 2009. The $2.7-billion submarine is 377 feet long and displaces 7,800 tons. She can dive to more than 800 feet and attain submerged speeds in excess of 25 knots. *New Mexico* and her sister Virginia-class submarines incorporate the state of the art in submarine technology. Features include photonic masts in place of periscopes, propulsors to replace propellers, and the latest in sonar and sound-quieting technology. Her motto, *Defendemos Nuestra Tierra*, means "We Defend Our Land." This photograph, showing the state flag flying from the bridge, was taken as the submarine departed on her initial sea trials. She is indeed a worthy successor to her battleship ancestor. (Newport News Shipyard.)

USS *New Mexico* (SSN-779) was commissioned in Newport News on March 27, 2010, and was delivered four months ahead of schedule. Here she is shown on commissioning day with USS *George H.W. Bush* (CVN-77) in the background. She is manned by a crew of 130, and her commissioning commanding officer was Comdr. Mark A. Prokopius. *New Mexico* is armed with four torpedo tubes designed for launching Mk48 ADCAP torpedoes and 12 vertical launch tubes that carry Tomahawk cruise missiles. The image below shows battleship *New Mexico* chief warrant officer George Smith (1939–1940) and Comdr. George Perez (commanding officer of the submarine from 2010 to 2013) at the BB-40 tribute table in the submarine's crew's mess. (Above, Newport News Shipyard; below, Rick Carver.)

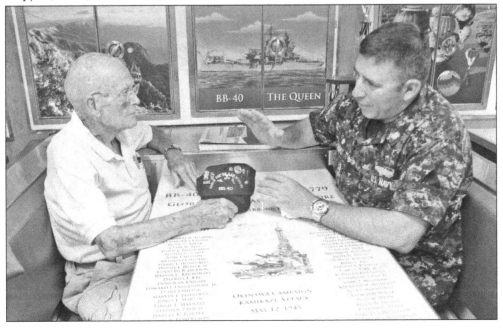

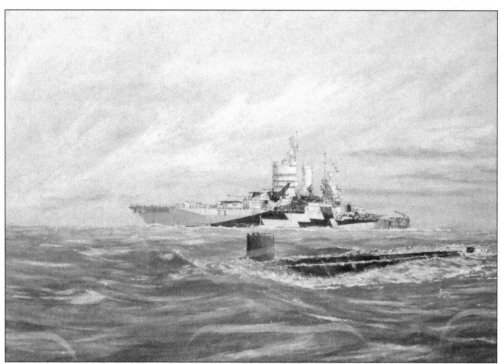

This painting imagines the attack submarine *New Mexico* escorting the battleship *New Mexico*. During World War II, battleships were escorted and screened by surface ships like destroyers or even cruisers. In today's world, aircraft carriers, the battleship equivalent in the modern Navy, are screened by nuclear attack submarines. The painting hangs in the wardroom of the SSN-779 and is shown here courtesy of that vessel and its crew. The day of the battleship may have ended, and the day of the nuclear submarine continues, but the legacy of *New Mexico* and the men who served aboard her will last forever. (Both, Dick Brown.)

BIBLIOGRAPHY

Bennett, Geoffrey. *Battle of Jutland*. London, UK: Endeavour Press, 2014.

Brown, Dick. "USS *New Mexico*: Glorious Past, Awesome Future." *La Cronica de Nuevo Mexico* 95 (April 2013): 1–2.

Driscoll, John C. *USS New Mexico (BB-40)—The Queen's Story in the Words of Her Men*. Bend, OR: Maverick Publications, 2009.

Friedman, Norman. *U.S. Battleships—An Illustrated Design History*. Annapolis, MD: US Naval Institute, 1985.

Garfield, Brian. *The Thousand Mile War—World War II in Alaska and the Aleutians*. Fairbanks, AK: University of Alaska Press, 1995.

Horne, Peter. *Battleships*. London, UK: Lorenz Books, 2014.

Mahan, Alfred T. *The Influence of Seapower Upon History, 1660–1783*. Mineola, NY: Doven Military Publications, 1987.

Massie, Robert K. *Dreadnought*. New York, NY: Ballentine Books, 1991.

———. *Castles of Steel*. New York, NY: Ballentine Books, 2005.

Office of the Industrial Manager, Navy Yard, New York. General Information: Battleship No. 40—USS *New Mexico*. 1920.

Stille, Mark. *U.S. Standard-Type Battleships, 1941–1945*. New York, NY: Osprey Publishing, 2015.

Terzibaschitsch, Stefan. *Battleships of the U.S. Navy in World War II*. New York, NY: Bonanza Books, 1977.

Wickland, John. *All the Queen's Men*. St. Louis, MO: USS *New Mexico* Association, 1990.

Wyler, Rear Adm. George Lester. "The Battle Flag of the USS *New Mexico*." *New Mexico Historical Review* 22 (January 1947): 1–7.

Visit us at
arcadiapublishing.com